The Campus History Series

MILLIGAN COLLEGE

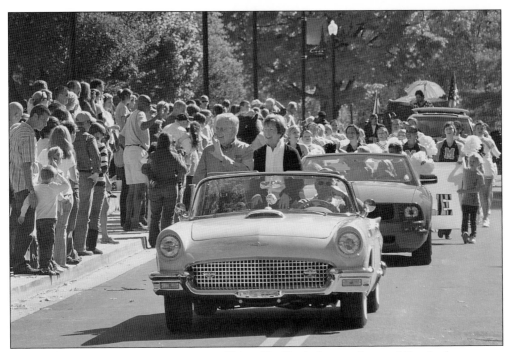

HOMECOMING 2010. Pres. Don Jeanes and his wife, Clarinda, are shown riding in the campus parade, greeting the crowd at Milligan College's homecoming event. Jeanes served as Milligan's 14th president and retired in 2011, having solidly built upon the institution's unique history and having impressively enriched its legacy during his 14-year term. As reflected on the streetlight flags, with growth and development accomplished under his leadership, Milligan College advances, "Forward Ever."

ON THE COVER: This photograph from the campus archives shows Milligan College students from about 1908 enjoying a snack and some fellowship on the lawn of what is known today as the Mary Sword Commons. A few faculty and staff members are seated in the shadows in front of Hopwood House, the Josephus and Sarah (LaRue) Hopwood home that was enlarged and utilized for many years as a residence hall.

The Campus History Series

MILLIGAN COLLEGE

JAN E. LOVEDAY
FOREWORD BY BILL GREER

ARCADIA
PUBLISHING

Published by Arcadia Publishing
Charleston, South Carolina

Printed in the United States of America

Library of Congress Catalog Card Number: 2011922885

For all general information, please contact Arcadia Publishing:
Telephone 843-853-2070
Fax 843-853-0044
E-mail sales@arcadiapublishing.com
For customer service and orders:
Toll-Free 1-888-313-2665

Visit us on the Internet at www.arcadiapublishing.com

Dedicated with appreciation to Dr. Don Jeanes, Milligan College president 1997–2011, for his graciousness, which exemplifies the Milligan spirit.

CONTENTS

FOREWORD

Emerging from the aftermath of the Civil War, the Buffalo Male and Female Institute grew to become Milligan College under the leadership of Josephus and Sarah (LaRue) Hopwood. The institution's mission of honoring God by educating men and women to be servant leaders remains central to its purpose, even today. Milligan has seen its share of challenging times over the years, but because of the loyalty of its alumni and friends and the hard work of its faculty, staff, and trustees, Milligan is now a thriving Christian liberal arts college whose students come from throughout the country and from around the world. Likewise, our graduates—whether they be doctors, lawyers, ministers, nurses, business people, artists, or teachers—live and work all over the world, having a positive impact upon their homes, churches, workplaces, and communities.

This book, with photographs chosen from the Milligan College archives accompanied by captions thoughtfully written by Jan Loveday, chronicles the fascinating history of Milligan, as seen through the eyes of the people who make Milligan College the remarkable family that it is. Our students, faculty, staff, trustees, and friends have nurtured and loved Milligan throughout her history and are a testament to the quality education, spiritual development, and career preparation that is the hallmark of membership in the Milligan College community.

Milligan's recent years have been described by many as the very best in the college's history. Due in large part to the remarkable leadership of Don Jeanes, Milligan's 14th president, the college has seen enrollment grow to record levels, academic programs expanded and improved, and campus facilities added and enhanced. Dr. Jeanes has guided Milligan to become nationally recognized as one of the best liberal arts colleges in the South. With his retirement in the summer of 2011, Dr. Jeanes leaves a legacy of success for the college to build upon as Milligan rises to the opportunities and challenges of the future.

As Milligan celebrates its 150th anniversary in 2016, the college is poised to continue its rich history and tradition of excellence, thanks to a community of people committed to honoring God in all that they do.

Bill Greer, PhD
President, Milligan College

ACKNOWLEDGEMENTS

I deeply appreciate all who have contributed to this project. My gratitude is extended specifically to Don Jeanes, who, as Milligan College president in 2010, gave his approval and affirmation. I am also thankful to Pres. Bill Greer and Vice Pres. Lee Fierbaugh for their support throughout the process. While I have made a genuine effort to fairly represent Milligan's story, I recognize that mistakes and omissions are inevitable. I apologize in advance for shortcomings, as I am sure it is missing people, details, and events that might otherwise have been included. Unless otherwise noted, all images come from the college's archives. I am indebted to the college's archivist, Meredith Sommers, for her patience and provision as she and her student workers made available the treasured photographs. Special to me is that among those students who labored in the scanning is my daughter, Jessi, who has grown and flourished on the banks of the Buffalo. Coach Duard Walker, who served for 50 years at Milligan in various capacities, has been a delightful source of institutional memory, and I thank him for his time. Historian Clinton Holloway provided much information and clarification, and I appreciate his input. Special thanks to the Phi Alpha Theta History Honor Society for their Today in Milligan History project, which celebrates Milligan's history.

My journey toward Milligan actually began with the efforts of my high school English teacher, Shirley Underwood, who used Foxfire series methods to inspire her students to research their community and heritage. She gave personal attention and encouraged me to attend college, where I earned a bachelor of fine arts degree and a master's degree in teaching. To honor her, I have attempted to pay it forward. Nurtured to have a sense of place, I have always enjoyed learning about and celebrating local history, pleasures I have sought to foster in my own students. This book is a natural extension of the curiosity and penchant for storytelling instilled by my parents and generations before them. For their support, encouragement, and reprieve, I note the love of family, specifically Jon, Jessi, Josh, and Hagen. To you, for your interest and investment, thank you.

INTRODUCTION

Milligan College is nestled amid the beautiful Appalachian Mountains of Northeast Tennessee. Located between Johnson City and Elizabethton in Carter County, the campus lies in proximity to all the urban conveniences and cultural amenities of the Tri-Cities, while also benefiting from the quiet and inviting retreats of nearby hiking trails, parks, rivers, lakes, and forest reserves. For many decades, Milligan students have been nurtured to grow toward their full potential in this setting.

The institution began as an early-1800s community effort to provide education to area young people. Sponsored by church members along the waters of Buffalo Creek, the school was established to equip and nurture its pupils to become contributing and responsible Christian citizens. Students educated at this site have performed throughout the decades in their various careers as servant leaders scattered across the nation and around the world to have positive influences. Its educators have been committed to ministering to the whole person, fostering development of intellect, body, and spirit, with a devotion to personal attention and a Christian liberal arts education. The college has grown from a single creekside building with a handful of students to a beautiful, expansive campus offering more than 30 majors, as well as master's programs and degree completion options, to over 1,100 traditional and nontraditional students.

Buffalo Creek Church was established in the Cave Spring community of Happy Valley when members of nearby Sinking Creek Baptist Church responded to Restoration Movement principles of reformers Barton Stone of Kentucky and Thomas and Alexander Campbell of Virginia. By 1830, a "field school" of 20 students was being held at the church. Field schools were rural elementary schools common on farms in the South before the Civil War. In 1851, Caswell C. Taylor and A.W. Taylor donated land on the west bank of Buffalo Creek and proposed a new building for religious and educational purposes.

The school survived the Civil War, and around 1866, Col. Wilson Gilvan Barker came to preach and teach at Buffalo Creek and expanded the school to an institution of higher learning. Isaac Taylor obtained a charter for the Buffalo Male and Female Institute, and a new two-story building was completed in 1867. While hundreds of institutions were established with similar missions during that era, it is among the few that have survived and thrived, and it has maintained its relationship with the Christian Churches and Churches of Christ.

The school was initially divided into primary, intermediate, and advanced departments, and besides the basics, classes were offered in French, Greek, and Latin. Beyond their regular studies and recitations, student activities included baseball, debating, and public entertaining in the form of music and drama.

After the Civil War, Josephus Hopwood and his wife, Sarah Eleanor (LaRue), left teaching among the Melungeons in Sneedville, Tennessee, to become administrators at Buffalo in 1875. Hopwood had a Methodist background, but his education at Abingdon College, a Disciples of Christ institution in Illinois, transformed his views. He attended Kentucky University's College of the Bible, where he was influenced by Prof. Robert Milligan, who instilled a missionary vision in his students. This experience molded Hopwood's conviction that Christian education was "the hope of the world," believing spiritual growth was central to wholeness and that character development depended upon it. With this devotion, the Hopwoods established their ministry in education.

Despite difficult financial challenges, the Hopwoods increased enrollment and grew the school, elevating it to collegiate status. They expanded buildings and hired additional

instructors. Morning chapel attendance was expected, and Bible teachings were integrated into all courses. The institute also included a primary department and a normal (teacher training) department, both considered temporary provisions until the state invested in public education. The normal course focused on principles of science, algebra, English literature, and classroom management, and the teachers in training were supervised while they were allowed to teach the primary students.

In 1881, the construction of a new classroom building commenced, and the name of the institution was changed to Milligan College in 1882 to honor the memory of Hopwood's former professor, Robert Milligan. College processes were standardized in order to better serve the students, while establishing financial stability, but money woes continued. The college tried innovative approaches to expand educational options and still keep tuition affordable. Enrollment grew, classes and faculty were added, and students loved their time at Milligan. Hopwood became involved with Prohibition efforts and took time to run for governor on the 1896 ticket. After 1903, circumstances and spiritual calling led the Hopwoods to other ventures in education in Virginia, Georgia, Florida, back to Virginia, and then again to Milligan, where they retired and lived out their last years.

Milligan experienced several transitions under six different presidents before the Hopwoods returned in 1915. The college established its first graduate program, began an outreach to ministers, and developed athletics. However, Mee Hall burned the same year the Hopwoods returned, and the school continued to struggle.

In 1917, Henry and Perlea Derthick came to Milligan as president and first lady. Henry immediately began fundraising, an effort that became paramount when the main college building burned a year later while being used by the Students' Army Training Corps. Derthick solicited support from influential figures such as J.C. Penney and Henry Ford, and with the help of many dedicated donors, three new campus buildings were erected within five years. During the 23 years the Derthicks were at Milligan, Perlea served in various capacities such as dietician, landscape designer, dean of women, and at times, as general manager in Henry's absence.

Among other strengths, flourishing athletic programs and the introduction of a Bible school institute marked the Derthick administration. During this time, Milligan secured senior college status. However, the students best remembered their Milligan time in that era for the knowledge they gained and the lessons in character building and etiquette, as well as the fun they had with pranks and the love, guidance, and proper discipline they were given. At the end of his term in 1940, Derthick left the college debt free.

Derthick's successor, Charles Burns, faced decreased enrollment as World War II called many of the college's young men off to battle, a situation that created financial strains. Burns made the difficult but patriotic decision to turn the college over to the US government for use as a naval base in the V-12 program. Milligan was the only college in the United States to relinquish its entire operation to the war effort. For this, Milligan was later recognized as an abandoned military post.

During the Great Depression, Milligan's subsequent presidents offered creative solutions to the financial demands of the times, while also offering quality academics. Athletic and music programs grew, and with the leadership of Pres. Dean Walker, the heart of Milligan's campus, Seeger Chapel, was completed in 1967. The humanities program, which is the trademark of the Milligan experience, was officially introduced in 1968. During Pres. Jess Johnson's implementation of his 10-year plan, enrollment increased and buildings were added, but the college faced mounting debt, as well as challenging national trends in higher education.

Marshall Leggett was president from 1982 until 1997, years during which he saved the college from financial collapse. He and his wife, Jean (Fritz), who served as his administrative assistant, worked hand in hand to advance Milligan. Several renovations, building projects, and property acquisitions upgraded and expanded the campus during his term. Athletics were strengthened by Duard Walker, whose roles as athlete, teacher, coach, head resident,

and, ultimately, athletic director, brought legendary status. Academic growth included a new nursing program and the seeds of Milligan's graduate and professional studies in the form of a new degree completion program for nontraditional students and masters programs in education and occupational therapy.

Don Jeanes became Milligan's 14th president in July 1997. Jeanes, an alumnus of Milligan, graduated magna cum laude in 1968. His wife, Clarinda, and their daughter, Amy, also earned their bachelor's degrees at Milligan. After his graduation, he then worked at Milligan in student life, financial aid, and the business office, while continuing his education at Emmanuel School of Religion, where he earned his master of divinity, with honors, in 1972. He served at Atlanta Christian College as a faculty member and administrator before being named administrative vice president from 1978 to 1984, years during which he did doctoral coursework at Emory University. Prior to becoming president at Milligan, he served as a Milligan trustee and in various ministerial positions in Tennessee and Texas, before returning to Johnson City as senior minister at First Christian Church.

During Jeanes's 14-year tenure, Milligan achieved record enrollment of 1,100 students and enlarged the campus to 195 acres. As part of his Central Campus project, initiated in 2001, Derthick Hall was renovated and the Mary Sword Commons was developed. Jeanes's wife, Clarinda, played a significant role in campus beautification and hospitality during his administration. Her appreciation for aesthetics and her genuine warmth benefited Milligan in many ways as the college grew and improved. Also renovated under Jeanes's leadership were the Paxson Communications Center, McCown Cottage, and the historic Taylor/Phillips House, as well as the Baker Faculty Office Center, to which the Paul Clark Education Center was added. Additionally, upgrades were made to several campus auditoriums, including Seeger Chapel. New buildings constructed during his term included the Physical Plant Center, the state-of-the-art Gilliam Wellness Center, the magnificent Elizabeth Leitner Gregory Center for the Liberal Arts, and the W.T. Mathes Tennis Center and its accompanying clubhouse.

Also during the Jeanes term, Milligan further developed its undergraduate majors and master's degrees and achieved professional accreditation for additional programs. Options for nontraditional students were increased, and new venues and methods of delivery were provided. Athletic programs and student services were expanded, the latter in large part through a $2 million grant from the Lilly Endowment. The college completed two successful capital campaigns, doubling the institution's endowment, establishing more than 100 new student scholarships, and increasing alumni giving to record levels.

The Jeanes presidency reshaped the college physically, academically, and financially to advance a mission of Christian education that has not changed since its inception.

Bill Greer, who assumed the Milligan presidency in July 2011, has an extensive and distinguished professional background in academics and business. He holds an MBA from East Tennessee State University and a PhD in economics from the University of Tennessee, Knoxville. As church elder and businessman, having served for many years on numerous corporate and community boards, Dr. Greer's experience provides a sound foundation for advancing the college. Greer graduated from Milligan in 1985 and joined the faculty in 1994, teaching economics, chairing the business area for several years, and leading the college's efforts to develop and establish Milligan's master of business administration. As vice president for institutional advancement, he successfully achieved annual fundraising goals and led Forward Ever: The Campaign for Milligan College, which exceeded its initial $25 million goal. His wife, Edwina, is also a Milligan graduate, and their two sons were students when Greer assumed the presidency.

Along with faculty, staff, and students, Don Jeanes and Bill Greer together have established and nurtured relationships with supporters of the Milligan College family, who have helped make the college what it is today. As the Christian education offered at Milligan continues to help foster "the hope of the world," Milligan College moves, in the words of its alma mater, "Forward Ever."

One

FOUNDATIONS AND
FORMATIVE YEARS

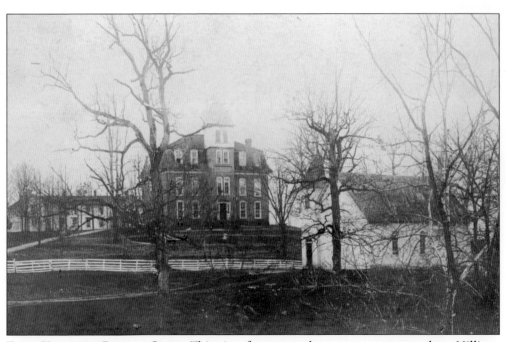

EARLY VIEW FROM BUFFALO CREEK. This view from near the campus entrance along Milligan Highway shows in the foreground what is now named Hopwood Memorial Christian Church prior to renovations and exterior stonework, along with the Classroom Building (center), which stood where Derthick Hall now stands. In the background is Hopwood House, the home of Josephus and Sarah (LaRue) Hopwood, after it was expanded for use as a residence hall.

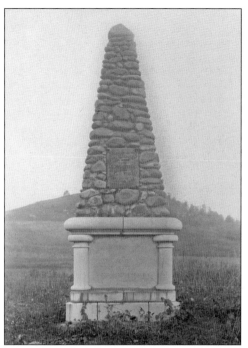

OVERMOUNTAIN TERRITORY. Milligan College sits within Carter County, an area known for its significant role during the Revolutionary War when the Overmountain men of the region marched to Kings Mountain (South Carolina) to defeat the British in a turning point of the patriot effort. Many Milligan graduates are direct descendants of the frontiersmen honored by this marker, erected in the early 1900s by local chapters of the Daughters of the American Revolution.

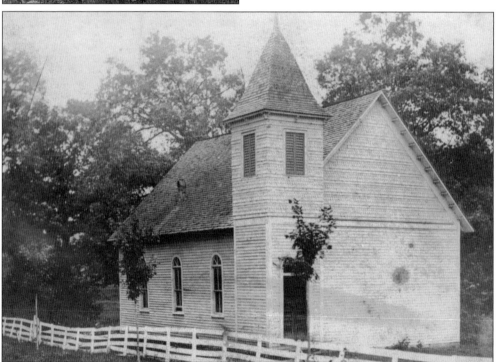

BUFFALO CREEK CHURCH. As the school's founding church, it housed the first classes in its original log structure, which burned in the late 1800s. This frame building (shown around 1910) was renovated and had a stone exterior added in 1938. It was then renamed Hopwood Memorial Christian Church. Throughout its history, it has been the church home of many Milligan faculty, staff, and students, and it continues to be an integral part of campus life.

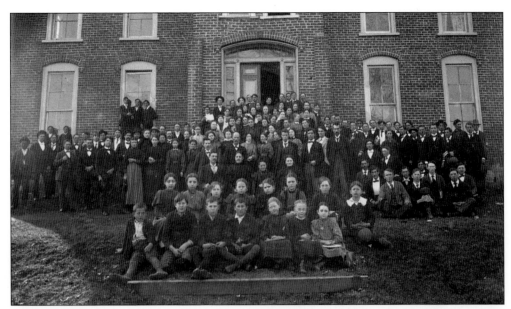

EARLY STUDENTS. As shown in this c. 1897 photograph, students at the earlier institution included children to young adults. Started as a field school or academy, it was taught by M.H.B. Burkett, but by 1857, James Boyd was its teacher, thus the community nickname, "Boyd's School." Mary Jane (Taylor) Kitzmiller, a member of Buffalo Christian Church, was its teacher during the Civil War. Ben Akard and Anna Bohannan were its 1871 principals.

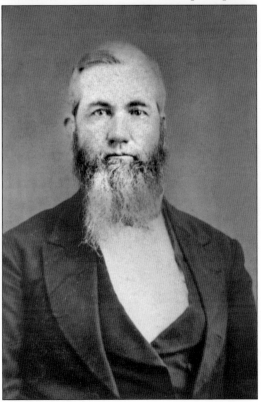

BARKER AND THE SHIFT TO HIGHER EDUCATION. Confederate veteran Col. Wilson Barker (1830–1905) became Buffalo Creek's new teacher and pastor and immediately began expanding the school, both physically and in mission, obtaining a charter for it as the Buffalo Male and Female Institute in December 1866. He remained with the Hopwoods as a trustee and taught at the college for much of his life, also funding a Bible room for the new building.

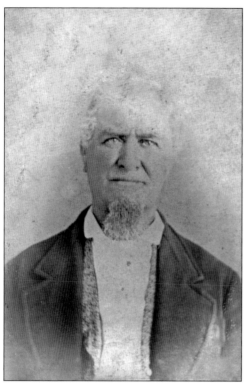

HE GAVE THE LAND. Joshua Williams gave the first acre of land for the construction of the Buffalo Institute building. He also sold six acres on a hill on Toll Branch to the institute's administrator, Wilson Barker, whose son married Williams's daughter. The Toll Branch residence additionally was used as student housing, as were the homes of most of the faculty and staff at that time.

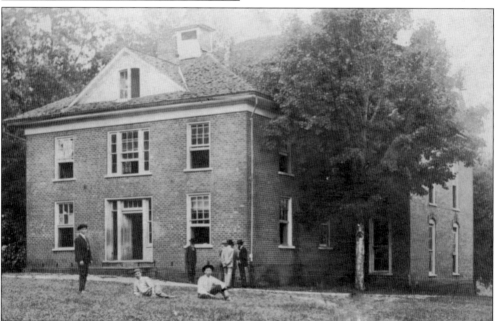

THE INSTITUTE. Shown here in about 1908 after the three-story 1881 structure was added, the Buffalo Institute building was constructed in 1867 under the supervision of local contractor J.D. Price, who used bricks fired on the premises. The project began with $1,553 of pledges made by 79 men. Originally consisting of one room on each of the two levels and later subdivided, it was used by the school and the church.

ROBERT LOVE TAYLOR (1850–1912). "Our Bob" Taylor, who served Tennessee as Democratic representative, senator, and governor, was a student at Buffalo Institute from 1869 to 1871, during which he was already enjoying public debate. He ran for governor against his Republican brother Alf Taylor (who had also been a student at the school) during 1886 in the campaign battle that became known as the "Tennessee War of the Roses."

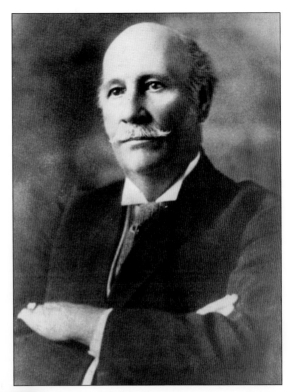

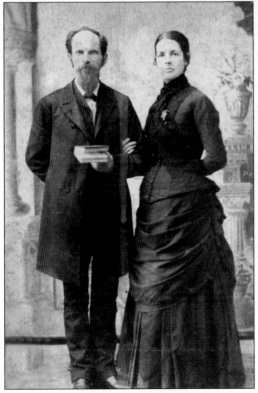

JOSEPHUS AND SARAH HOPWOOD, 1886. After three years of Union service in the Civil War and a few years of uncertainty about his vocation, Josephus Hopwood pursued training as a teacher. His education under Disciples of Christ leaders led him to minister in the war-torn South. He and his bride, Sarah Eleanor (LaRue), were teaching among the Melungeons in Sneedville, Tennessee, before becoming administrators at Buffalo Male and Female Institute at Cave Spring, Tennessee, in 1875.

GROWTH BY FAITH. According to campus lore, when Sarah Hopwood joined her husband on campus in 1875, she stuck her riding crop into the ground where they offered a prayer of dedication upon the school. Initially forgotten, the locust switch sprouted and grew into a large tree that was later bolted together after storms threatened to split it. It fell in the 1930s, but new saplings and related stumps remained on the hill until the 1990s.

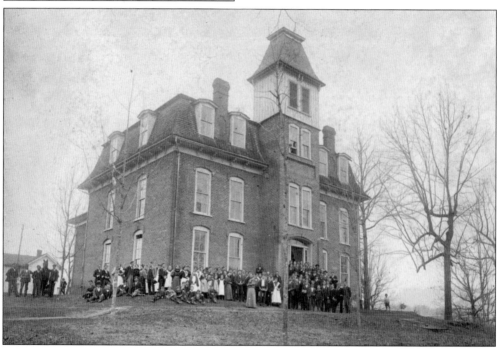

MORGAN AND MILLIGAN. In Milligan's early years, horses (note the one at left of the building in this 1896 image) were an important part of the culture. Josephus Hopwood stated in his autobiography that his horse, Morgan, helped develop the college. Morgan was a gentle, light chestnut sorrel who stood 14 and a half hands high. Hopwood rode Morgan many miles while recruiting students and raising funds. Eventually, he also sold Morgan to help pay campus bills.

PLOWING AHEAD. Josephus Hopwood traveled by horseback throughout the rural area surrounding Buffalo Mountain (shown in background), persuading young people and their parents of the value of a good education. Farm work ethics, skills, and products often provided the way for students to earn their stay on campus, and from such industrious efforts, enrollment immediately grew to 85 and then doubled within four years. Enrollment in 2010 broke records with over 1,100 students.

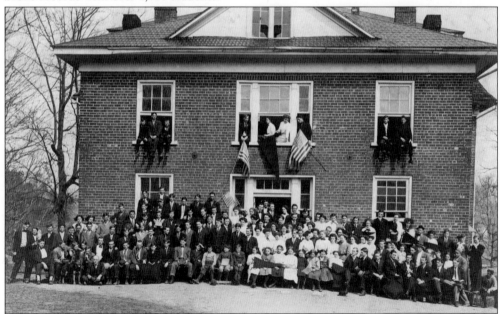

STUDENTS OF ALL AGES. To help provide education to the region, a normal school for training teachers allowed the college students to practice their methods with the younger ones on campus. Milligan remains an area leader in teacher education, and in addition to its traditional program, offers nontraditional tracks with degree completion options, as well as graduate studies for individuals seeking professional development, initial licensure, or additional endorsements with a master's degree.

Seven Points
For
Good Students

1. Be truthful at all times and everywhere. Truth is the foundation stone of good character.

2. Be clean in thought, in word, in life. Without this quality no one can be a first-class student.

3. Be industrious, willing and determined to try, and keep on trying. Idle and slothful habits choke out the better qualities. Weeds grow without effort. Food crops require diligent, persistent cultivation.

4. Be systematic and economical in division and use of your time in study, in labor, in recreation. To allow intrusions upon study hours by casual visitors who spend their time in small talk, will lower your ideals and hinder you from reaching your best.

5. Have care as to food and sleep. Over-eating produces drowsiness, indigestion, impure blood and consequently poor study. The want of sound sleep brings nervous irritation and hinders mental concentration, which a student must have to accomplish anything worth while.

6. Keep in a cheerful, hopeful state. This helps to build ife and give power. It is like sunshine to the plant or music to the soul.

7. Have faith, vision, purpose. The student must have vision of something; he wants to lead his class, to know much, to be a great man; then he must have faith that he can reach his end. And, last, he must have a deep heart purpose to reach his aim even though it costs sacrifice.

These seven points, well studied, will help any young man or woman to a fuller, happier life.

Dickson Printing Co., Johnson City, Tenn.

ACADEMIC EXPECTATIONS. No area public schools existed when the Hopwoods arrived at the Buffalo Institute, where their students were divided into departments: primary, preparatory, normal, and college. Their innovative "Monday holiday" was implemented when they noticed poor student performance on Mondays, after tiring Saturday chores and Sunday church activities; therefore, they held classes on Saturdays and had Mondays free, a tradition that continued until 1964. The *Seven Points* Hopwood publication shown here was printed locally in Johnson City and found among Hopwood's papers when 13 boxes of their belongings were discovered by maintenance foreman Arnold Milam in a garage being remodeled in 1955. Sorted and salvaged by Milligan librarian John Neth Jr., the remaining part of the collection not ruined by mice, water, and silverfish includes, among many other items, college rosters and receipts, student essays, and letters dating back as far as 1868. These artifacts are available in the Milligan College archives.

ROBERT MILLIGAN (1814–1875), C. 1850. Born in Ireland and impacted by Thomas and Alexander Campbell and the Restoration Movement, Milligan was a professor at College of the Bible in Lexington, Kentucky, where he taught his students that learning should prepare them for Christian service. He had such a great influence on the life of Josephus Hopwood that in 1881, Hopwood renamed the Buffalo Male and Female Institute after his mentor, christening it as Milligan College.

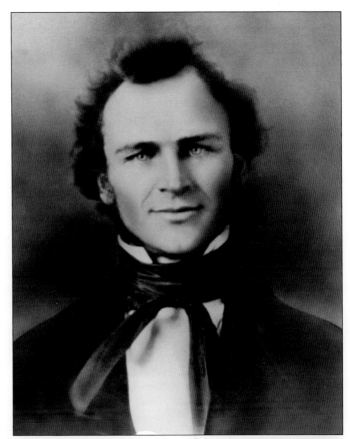

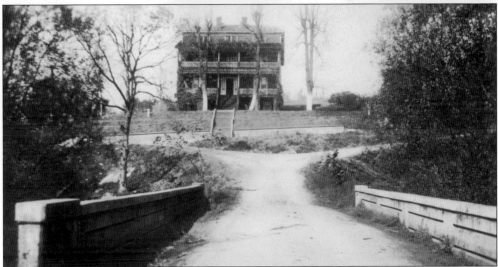

HENDRIX HOUSE. It was originally called the Big Boarding House because it was built as living space for female students and the host family, the evangelist Samuel Shelburne and his wife and 10 children. Shelburne had introduced the Hopwoods to Buffalo Institute. Constructed by the men of the college in 1880, the house featured three stories and a basement. Later owned by the Hendrix family, it was remodeled in 1916 and then housed male students.

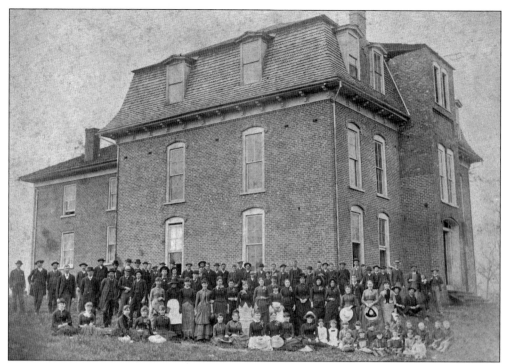

CLASSROOM BUILDING, C. 1896. The cornerstone was laid on commencement day, April 21, 1881, when the institute's name was changed to Milligan College. With 150,000 bricks handmade and fired on the premises by T.C. Hoss, the structure was added to the existing two-story building and was "dedicated to Christian education." Henry Crouch oversaw the construction of the facility, which housed the chapel, classrooms, an auditorium, the library, and society halls.

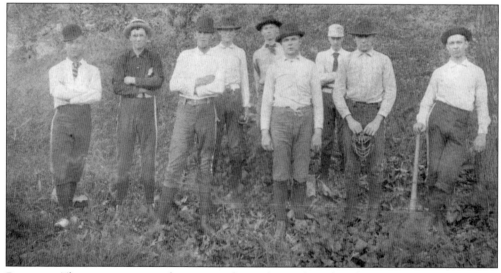

BASEBALL. The sport was popular among the early rural students, and as a regular pastime campus activity, it became Milligan's first intercollegiate sport in 1887. However, President Hopwood stopped such competition that same year because of an incident concerning an opposing team's conduct, and it did not resume until the Hopwoods left in 1903.

CLASS OF 1887. From left to right are (seated) James Giles and Eugene Crouch; (standing) Edward Wilson and Lettie Cornforth. The first graduating class in 1882 consisted of 10 individuals, and the smallest class consisted of only one student in 1896, a year of national economic depression. Milligan has grown to annually graduate more than 250 students at the bachelor's and master's levels.

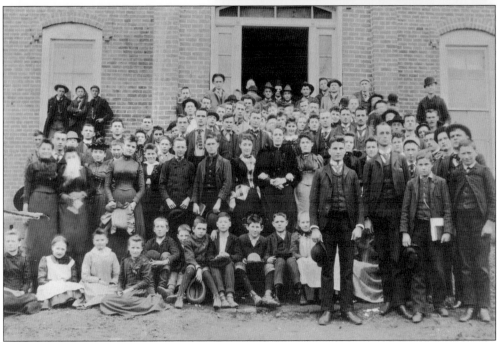

DEVELOPMENT AND STABILITY. In 1889, the building debt was eliminated, so the college then purchased the Hopwoods' home, which had served as housing for young women on campus. Sarah Hopwood is shown in the center with arms linked by students. Their disciplined but fair approach to management and leadership earned the Hopwoods great respect and much love throughout their lives.

HOPWOOD HOUSE. Also called the "Young Ladies Home," the Hopwoods' residence began as a two-room house rented from Samuel W. Hyder. They soon bought the home and added a shed room at one end for kitchen and dining space. They also closed in a porch, then later connected it to small adjoining houses and built a second story over all, with the pictured double porches on the inside of the resulting "U" shape.

YOUNG LADIES, 1891. The great responsibility of overseeing a coeducational institution in the 1800s was met with strict codes for behavior and high expectations. Pranks were not well tolerated, though they persisted and were remembered with great humor. Teachable moments about Christian character were addressed with love and conviction. A handbook was written for ladies' conduct, and in 1901, a women's dress code was established. For several years, a uniform was required.

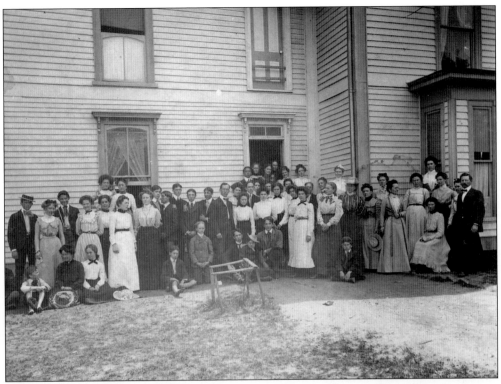

STUDENTS OF THE BIBLE, C. 1902. By the time this photograph was taken, all students were required to have a year of Bible studies. Even though Bible teachings were integrated throughout the curriculum from the school's inception and everyone was required to attend chapel, Bible was not a class in itself until 1892. In 1896, a school of Bible was established within the college.

No._____ _____189	No._____ _____189
State_____County.	*This is to Certify, that*_____
PROHIBITION ELOCUTIONARY CONTEST.	*of*_____*County*_____*State of*_____
Certificate of Successful Competitor.	*received the award of the* DEMOREST MEMORIAL_____MEDAL *in the*
Contest held_____189 ,	**PROHIBITION ELOCUTIONARY CONTEST,**
at_____	*held at*_____*on*_____189 ,
Name,_____	*in conformity with the statements on back hereof.*
Address,_____	*Age,*_____*years.*
Age,_____*years.*	*Subject,*_____
_____	_____
_____	*Chairman.*
_____*Chairman.*	CERTIFICATE OF SUCCESSFUL COMPETITOR.

(Vertical text: MEDAL CONTEST BUREAU, 10 E. 14th ST., NEW YORK.)

HOPWOOD'S PROHIBITION EFFORT. Strong objection to alcohol was controversial in a region known for its moonshine, but even Hopwood's land transactions forbade the production or sale of it. In 1895, the Hopwoods left to help their nephew and former student/teacher, James Tate, produce the prohibitionist paper the *Pilot*. During their year-long absence from Milligan, Josephus ran for governor on the Prohibition ticket but was defeated by a former Buffalo Institute student, Democrat Robert Taylor.

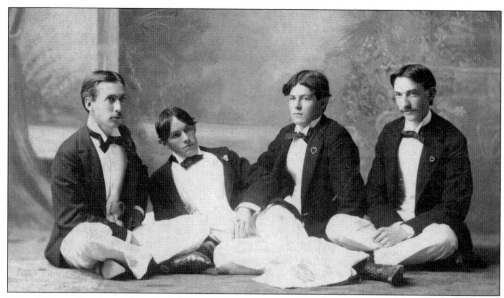

MALE VOCAL QUARTET, 1895–1896. From left to right, students Jim Owings, Joe Combs, Jim Thomas, and Tom McCartney sang temperance songs in support of the 1896 Prohibition Party's Tennessee gubernatorial candidate Josephus Hopwood, who witnessed much alcohol abuse during the Civil War. Milligan's more recent a cappella group, Heritage, is its premiere traveling ensemble, consisting of eight auditioned members who sing throughout the community and around the country, sharing the Milligan spirit.

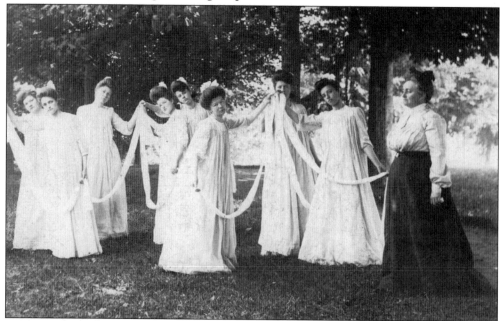

MAY DAY, C. 1896. The May Day play, presented at the end of the school year, was a much anticipated traditional campus event for about 100 years. Olive Garrett, far right, was the wife of faculty member Henry Garrett, who later served as Milligan president. The Garretts oversaw the young ladies' residential housing, and Olive sometimes taught instrumental and vocal music.

WILLIE GODBY TABOR'S SHORTHAND CLASS, C. 1897. In 1880, the Buffalo Institute's seven-person teaching staff included the president, his wife, and two upper level students, James A. Tate and James F. Swingle, who helped teach the lower level subjects. Milligan has grown to employ more than 75 faculty and offers more than 30 majors, as well as graduate and professional studies programs for nontraditional students.

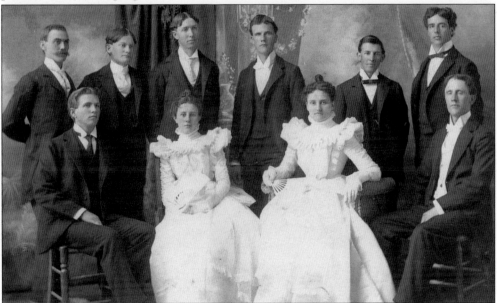

CLASS OF 1898. Life at Milligan forges positive relationships lasting a lifetime. In 1891, 25 graduates met to form the first alumni association. James Smith of Milligan's first graduating class was chosen as president, and Henry Garrett (class of 1889) served as secretary. The group planned to meet every three years for fellowship, and in 1937, a more regular group began. In 2010, Milligan reported more than 11,500 living alumni.

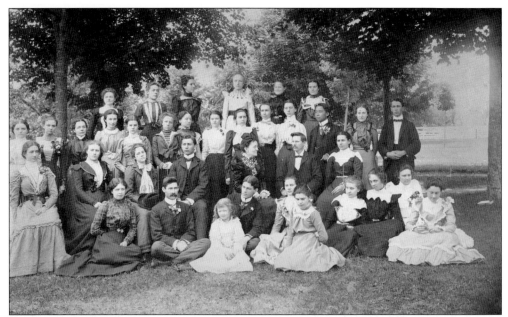

STUDENTS, 1899–1901. Shown standing third from the right in the third row is Lew Sue Ben, who was Milligan's first international student, from China. Early students most often came from surrounding states, but soon they came from all across the country and around the world. More than 10 nations typically are represented annually in Milligan's contemporary student body.

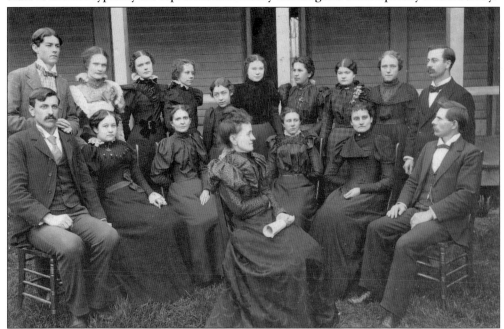

SALLIE WADE DAVIS'S MUSIC CLASS, C. 1899. Also among the studies in the early years were geography, history, composition, grammar, physics, philosophy, algebra, physiology, Latin, Greek, zoology, rhetoric, debating, drawing, painting, and trigonometry, just to name a few. Milligan's catalog has grown to list hundreds of courses, and delivery has evolved to include online studies, interactive television, and off-campus classes.

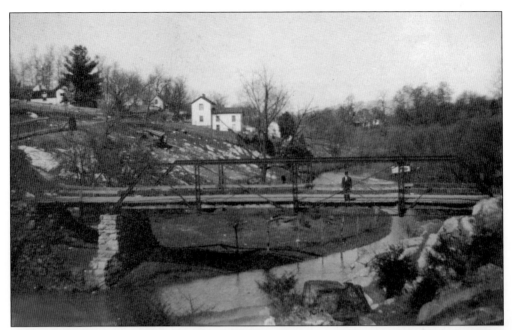

BRIDGE AT CAMPUS ENTRANCE, C. 1900. In 1880, when a student boarding house (Hendrix) was constructed on the bluff across the present highway from campus, an iron bridge was built to replace the old foot log across Buffalo Creek. With updated bridges throughout the decades, the site has remained a favorite spot for students and has been developed over the decades to include a dam, waterwheel, and gazebo. The entrance is a Milligan icon.

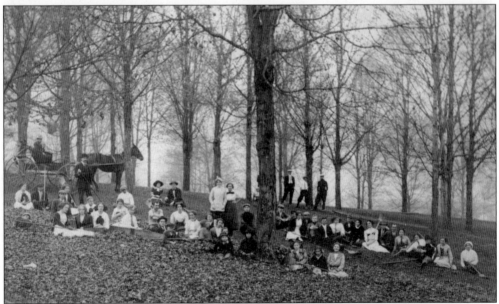

EARLY TRANSPORTATION, C. 1901. This campus scene of students and a horse and buggy was photographed during a time when few individuals had cars. However, even as late as the Derthick administration, students were not allowed to have automobiles on campus. More recently, about 1,000 cars are registered annually, and approximately 15 percent of traditional undergraduate students are commuters.

MILLIGAN WOMEN'S TEMPERANCE CHAPTER. The Women's Christian Temperance Union, founded in Ohio in 1874 by Francis E. Willard, began as a movement in opposition to alcohol, tobacco, drugs, and prostitution, but it also served as a social organization. Other campus groups for that era included literary societies such as the Philomathean and the Tibiserian, as well as clubs related to specific interests. The Hopwoods forbade secret organizations, which were popular at that time.

FACULTY, 1902–1903. Seated in the first row, from left to right, are early instructors Gilbert Easley, Josephus Hopwood, Sarah Hopwood, and Rosa Cornforth. Standing in the second row, from left to right, are James Thomas, H.R. Garrett, Sue Brummett, Elma Ellis, Carrie Hopwood, Wesley Cahoon, E. Gilbert, Sallie Wade Davis, and Cordelia Hopwood. More than 75 percent of Milligan's modern faculty hold the highest degree in their field, and they are actively involved in scholarship and service beyond the classroom.

Two

CHANGES AND CHALLENGES

HENRY RUFUS GARRETT. An 1889 Milligan graduate strong in mathematics, Garrett was immediately hired by Josephus Hopwood as professor of the subject. After earning his master's degree, he became president of Stuart Normal College in Virginia but soon returned to Milligan. After the Hopwoods' 1903 departure, Garrett was elected Milligan's president, but failing health caused him to leave in 1908. He is shown here in about 1899, seated second from the right.

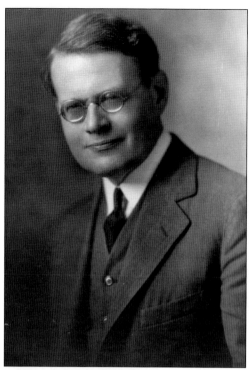

FREDERICK DOYLE KERSHNER. Kershner became Milligan's president upon Garrett's departure. A successful fundraiser, Kershner quickly addressed the cost of building the new Mee Hall for women. With student enrollment at a record high for the time, he increased land holdings and expanded both men's and women's athletic programs. He left Milligan in 1911 to become president of Texas Christian University.

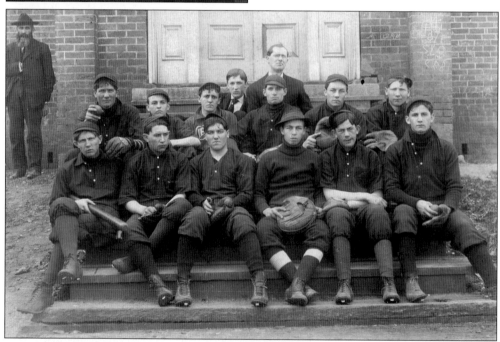

1906–1907 BASEBALL TEAM. The players are, from left to right (first row), George Bowman, Steve Peck, Jim Burton, Dave Taylor, John Suthers, and Carl Burleson; (second row) Charles Adams, Ben Taylor, Victor Lewis, Tom Warrick, Frank Kelly, and Douglas Crouch; (third row) John Anderson and unidentified. Under the direction of Coach W.P. Dungan, the 1910 team was the first to play a full season.

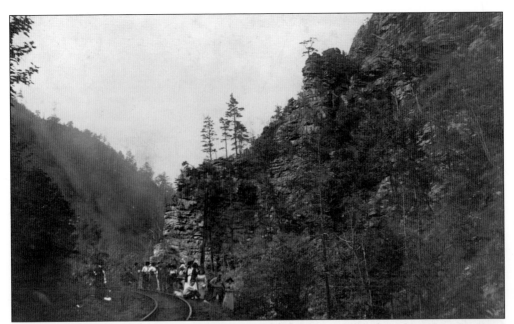

TWEETSIE RAILROAD EXCURSION, C. 1907. A quarter mile east of Pardee Point in Doe River Gorge, students enjoyed a stop along their Cranberry, North Carolina, Tweetsie Railroad trip, sponsored by George W. Hardin, general manager of the Eastern Tennessee and Western North Carolina Railroad. A portion of the railroad is preserved at Doe River Gorge Ministries, a camp/retreat where Milligan student events have been held.

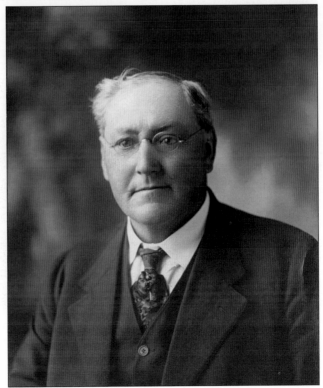

"INTELLIGENT WORK, WITH PRAYER." As a member of its first graduating class, George W. Hardin's words reflect his approach in supporting Milligan. He became vice president of Eastern Tennessee and North Carolina Railroad and served as Milligan treasurer and trustee. As a major benefactor over the years, he raised money and championed the college's cause. He also once sold his life insurance policy and even mortgaged his home in order to give. Hardin Hall is named for him.

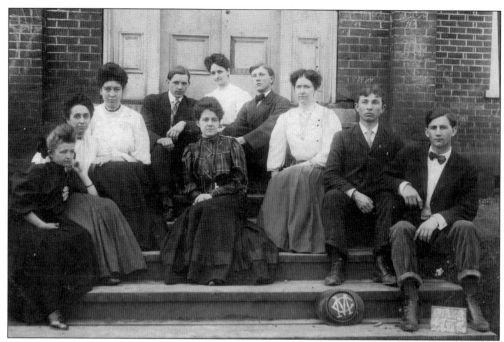

GERMAN CLASS, 1907–1908. Anna Beatrice Grayson, teacher of ancient and modern languages, is shown at center, surrounded by her students (from left to right), Stella Lee Sutton Burleson, ? Birch, Alta Agnis Carpenter, George Robert Lowder, Maggie Wright, George Bowman, Persie Owen, Alvin Combs, and Carl Edward Burleson. Through the years, German has been taught by Dr. Earl Stuckenbruck, Dr. Donald Shaffer, Rosemarie Shields, and Dr. Ted Thomas.

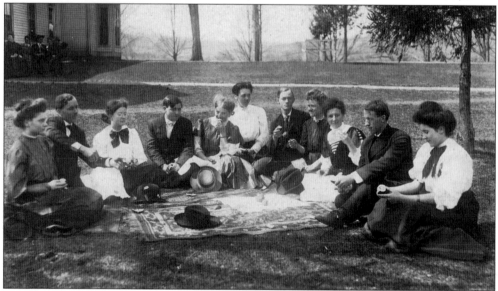

STUDENTS FROM VIRGINIA. Seventh from left is Raleigh Harrison Tabor and tenth is Wise Worrell. For several years, students had a club called the Virginians. Other clubs over the decades included the Zelotai, which consisted of wives of students and faculty of the religion department; Pi Kappa, consisting of preachers' children; and Civitan and Circle K, sponsored by the local related civic groups; as well as judo, ski, psychology, and poetry clubs.

POWERHOUSE. Milligan's early reputation in baseball developed as a result of its triumph over the University of Tennessee and Vanderbilt, making the 1909–1910 team undefeated. Willard Millsaps and several players from the 1920s teams later played professionally. As part of a winning heritage throughout its various athletic programs, Milligan won more than 50 conference titles and made over 50 national tournament appearances in the 2000s.

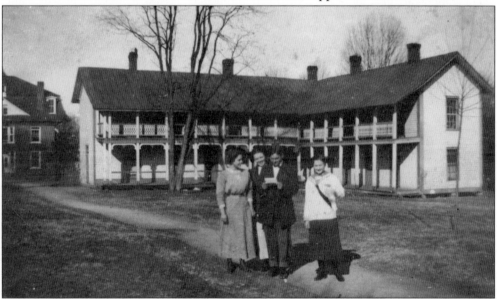

HOPWOOD HOUSE, C. 1908. Located between the classroom building and the site of Hardin Hall, the Hopwoods' house and grounds were sold to the trustees in 1890. In 1886, its upstairs could accommodate 40 female students, who paid $114 annually for boarding, tuition and fees, washing, trunk transporting, and mail services. It became a male residence hall, and the dining wing was removed as Mee Hall was completed in 1908. It was deconstructed in 1913.

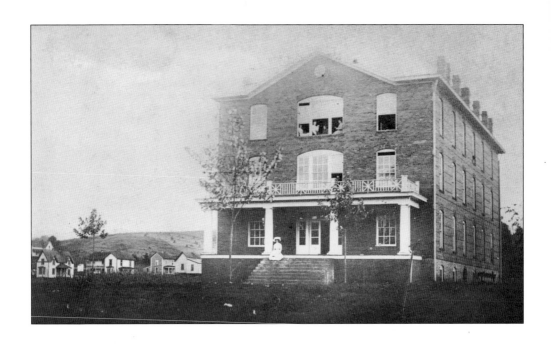

MEE HALL. In 1907, support from devoted donors like George Hardin allowed construction to begin for Mee Hall, located near the site of the later-constructed Science Building. The Columbus A. and Frances T. Mee Memorial Hall was completed in 1908 and named in 1910, when Frances Mee gave money to retire the building debt. Mee Hall housed female students until they were moved to the new Hardin Hall in 1913. The dorm had 32 rooms, a parlor, reception halls, the campus dining room, kitchen, storerooms, and amenities such as steam heat, electric lighting, and a large attic water tank that supplied the campus with water via an automatic hydraulic pump located on the athletic field. After Mee Hall burned on Christmas Eve in 1915, Mee Chapel in the Administration Building was named to recognize Frances Mee's contributions to Milligan.

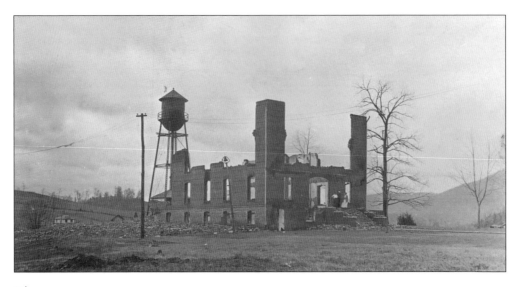

MINISTERIAL STUDENTS, 1909–1910. In the first row, from left to right, are Walter Taber, Jimmy Stephens, and Ira Allamong; in the second row are Tollie Thomas and Lamberth Hancock. From its founding, the college's Christian emphasis has resulted in many students choosing paths in ministry. The long-established Ministerial Association (initiated under the sponsorship of professor A.I. Myhr) and its female counterpart, the Volunteer Band, provided a church service network and offered fellowship and support.

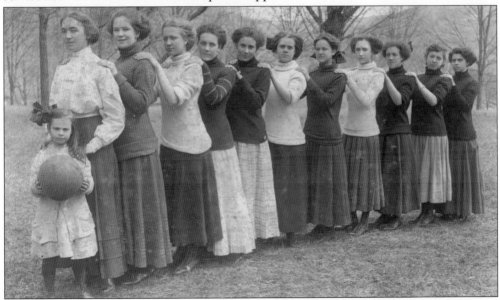

WOMEN'S BASKETBALL, 1910. First nurtured under the Kershner administration, Milligan's athletic programs have continued to grow in opportunities and reputation throughout the years, and women participated in its physical education activities even in the early years. Basketball teams initially improvised with an outdoor court at the end of the football field but eventually moved indoors when the Classroom Building was enlarged in 1912 and the old chapel was converted to accommodate the game.

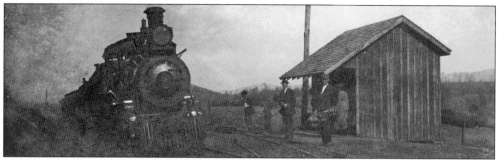

MILLIGAN STATION, C. 1910. The railroad was an important early form of transportation for students, and this station was located in Happy Valley, probably along the tracks near where Cedar Grove Road turns toward Milligan Highway. In 1909, Robert Milligan's son, Alexander Reed Milligan, gave $5,000 for a permanent endowment fund and also asked at that time that the station name be changed from Milligan to Milligan College.

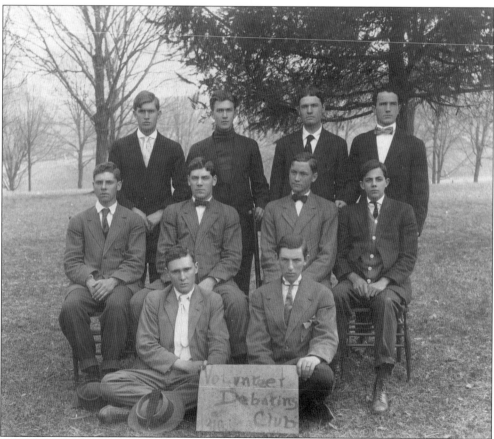

VOLUNTEER DEBATING CLUB, 1910. Debating was a favorite student activity as early as the mid-1800s, and it helped equip many Milligan graduates for securing various public offices. Those in political service at the state and national level have included governors Alf and Robert Taylor, who were brothers, and Alf's son, Judge Robert Taylor; Oklahoma state senator Tom Anglin; and congressmen Dayton Phillips, Dan Carroll, and David Davis.

CAMPUS WORKDAY, 1911. The faculty and staff campus workday tradition of preparing the college for student arrival finds its roots in the Hopwoods' Arbor Day of cleaning and beautifying the grounds. Classes were cancelled on a pretty day so that students could also go into the woods and choose a sapling to plant. Many large campus trees are the result of that student effort and were lovingly remembered by those who planted them.

ROOTED IN THE HEART. This marker was placed at the base of a maple tree planted on a campus workday in the late 1800s near what eventually became the McCown Cottage parking area. Also affectionately referred to as "tree day," the tradition appears to be the forerunner of the more recent annual student holiday known as Wonderful Wednesday.

"A TEACHER OF RARE POWER." Tyler Utterback served as minister and educator in various states before coming to Johnson City as superintendent of public schools and then to Milligan in 1910 as academic dean. Because of his work to elevate academic standards, he was selected to succeed Frederick Kershner as president in 1911, serving until 1913. During that time, Hardin Hall and the president's home (later McCown Cottage) were built while the Classroom Building was remodeled.

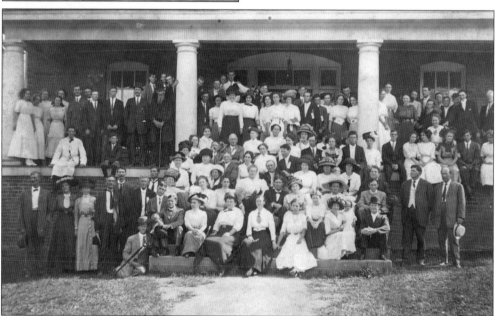

CHRISTIAN CHURCH TENNESSEE CONVENTION, 1911. Shown on the steps of Mee Hall, the conference members represent a gathering of congregants from across Tennessee. For many years, Milligan's Board of Trustees was elected from the Tennessee Convention. Later, the college charter was rewritten to provide for a self-perpetuating board. Today's board includes 37 men and women, representing church, alumni, and business backgrounds.

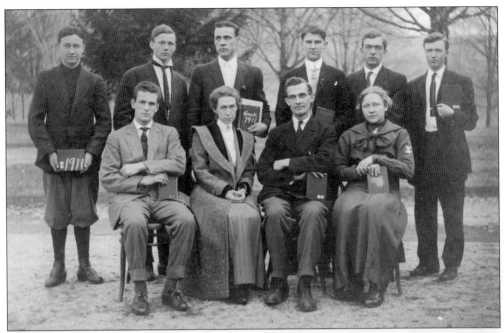

GREEK CLASS, 1911. Early Buffalo Institute students were charged $12 for Greek as an advanced class, but a working knowledge of the language was later required for entrance to the college department. Subsequently recommended to all students in ministerial and biblical studies, Greek began to be offered as a major and minor. In recent years, Greek has been taught by Professors Lee Magness and Susan Higgins.

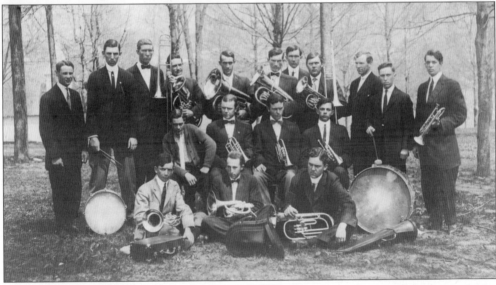

BAND, 1912. Music has always been important to the Milligan experience, and student activities of the time included band and orchestra options, as well as several singing groups. Music programs have grown throughout the decades to include eight instrumental ensembles and two choral ensembles, as well as the a cappella group Heritage. Milligan has collaborated throughout the years with the Johnson City Symphony Orchestra, which has performed regularly in Seeger Chapel.

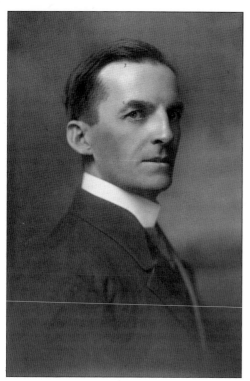

ONE YEAR TERMS. After a decade of service at various institutions, Errett Weir McDiarmid (1877–1937), shown at left, became Milligan's president upon Tyler Utterback's resignation in 1913 during a multiple building construction program on campus. McDiarmid left after only one year but remained in education to serve many years in academics and athletic administration at Texas Christian University. He was also a scout for the Cincinnati Reds baseball club before his death in Texas. After several years of ministry and religious studies, Harvard-educated James Tracy McKissick (1874–1957), shown below, became secretary of missions for Tennessee Christian Missionary Society, and under his evangelistic leadership, about 5,000 members were added to Tennessee Christian Churches. In 1914, he was selected as president of Milligan after having led several evangelistic meetings at Buffalo Creek Christian Church. Though his presidency at Milligan lasted only one year, he later served as president at other institutions.

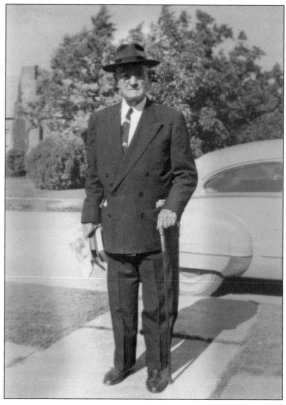

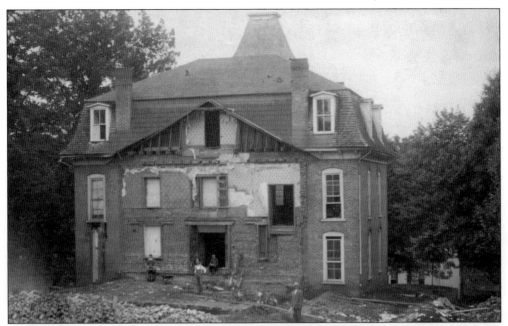

BUFFALO INSTITUTE BUILDING REMOVED, 1913. When the old building was torn away, the Classroom Building was remodeled and a new section was added. Throughout its history, Milligan has attempted to renovate and update existing facilities in order to be a good steward of its resources and its heritage. For example, McCown Cottage, also built in 1913 as the president's home, was later used for dorm space, the admissions office, and then as the college's business office.

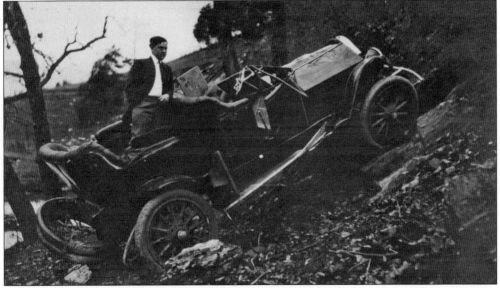

WRECK ON THE BUFFALO, DECEMBER 1913. In 1890, the Hopwoods purchased the Cameron farm along Buffalo Creek across from campus and blasted the bluff to allow for a shorter route to Johnson City, hoping to sell small tracts of land to financially benefit the college. The steep highway access in front of Milligan was improved in 1970, but a section of retaining wall can still be seen on the hill, indicating the road's original path.

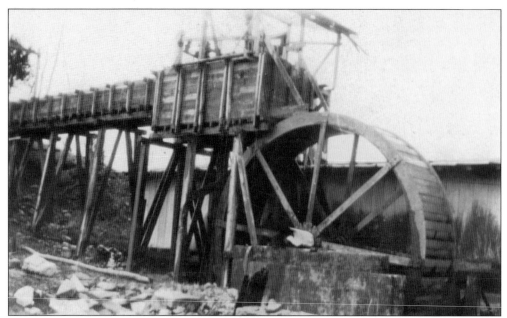

MILL, 1913. George Hardin helped raise $50,000 to improve Milligan's campus, and with part of the funds, the trustees invested in the Anderson Fine Flouring Mill and its 20 acres adjoining Milligan land east of the campus entrance. They hoped that students might farm the land and help provide for their educations. Another mill was located on Buffalo Creek near Anglin Field.

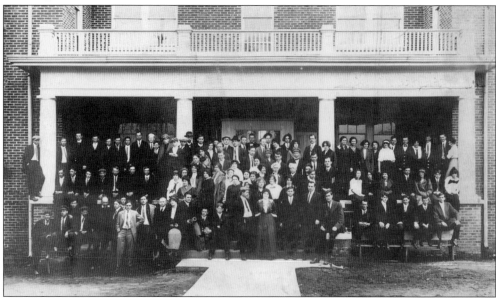

CHRISTIAN CHURCH TENNESSEE CONVENTION, 1913. Participants are pictured at Hardin Hall. Throughout its history, Milligan has maintained an active relationship with the Christian Churches/Churches of Christ, which are committed to the restoration of New Testament Christianity and the unity of all believers. The Church Relations Office, established in the 1970s and originally funded by the Phillips Trust, has helped promote and nurture church support throughout the years, and the campus regularly hosts related events and meetings.

Three

GROWTH AND GREATNESS

THE HOPWOODS RETURN.
Josephus and Sarah (LaRue)
Hopwood returned to Milligan
in 1915 for a two-year interim,
during which they dealt
with the aftermath of the
Mee Hall fire. Other campus
buildings were renovated
to compensate for the loss
of the kitchen, dining, and
living quarters. A men's track
team also was established
during the 1915–1916
school year, but Hopwood
maintained his opposition
to a football team, based on
philosophical reasons.

43

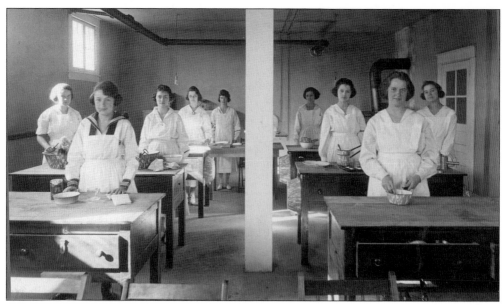

DOMESTIC SCIENCE. Mary Hardin, daughter of trustee and benefactor George Hardin, directed the home economics department, which was established during President McDiarmid's term. The related domestic science club enjoyed active membership for many years. Housed in the basement of Hardin Hall, the classroom was transformed into a campus kitchen and dining area when Mee Hall burned in 1915.

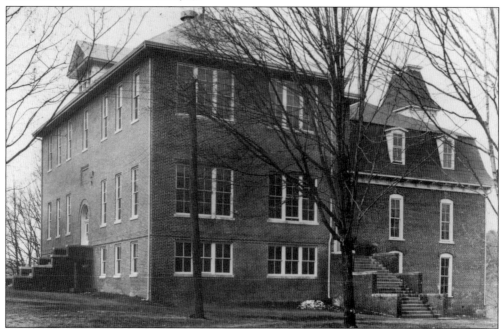

CLASSROOM BUILDING, 1915. Renovated as the college grew, it first contained classrooms, a chapel, the library, and society halls, and later held the bookstore and science laboratories. When a new chapel was created in the post-1913 addition, the old one was converted into a gymnasium, and heated showers were added on the first floor. The building burned in 1918, but east wing walls were salvaged for construction of a new building.

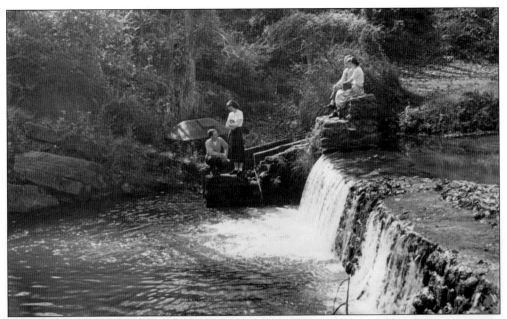

PRESIDENTIAL STEPS. Sarah (LaRue) Hopwood is credited with asking that concrete steps be built down to Buffalo Creek and inscribed with the names of American wars and US presidents up to that time so that students could learn history even as they walked there. Constructed by Millard Burleson and lettered by Tollie Thomas in about 1915, the steps (shown here in about 1950) have become worn and the lettering faint.

THEATRICAL GROUP. Student activities have included dramatic presentations since the school's inception, but an official Dramatic Club was founded in 1919. Other related groups were the Masque, allowing only students who had held leading roles or made significant contributions in a certain number of plays, and Apha Psi Omega, a national honorary theater society. Professors Dimple Hart, Marguerite Parris, Ira Read, Rosemarie Shields, and Richard Major have helped generations explore theater arts.

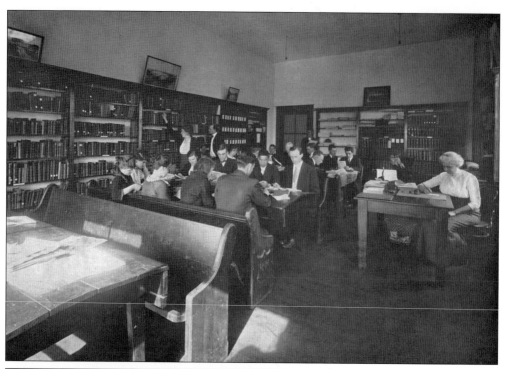

LIBRARY, 1917. Early students were charged 50¢ per term to use the reading room and its books and periodicals. By 1884, students had free access to the library, and a full-time librarian was added in 1898. In the 1918 Classroom Building fire, the library lost 150 books, but by 1919, it boasted 1,500 volumes. P.H. Welshimer's 7,000 book library, donated after his death in 1957, helped boost Milligan's collection to accreditation standards.

DR. HENRY DERTHICK. Henry and his wife, Perlea, served the Christian Woman's Board of Missions in several educational mission projects, as well as in various churches and other educational institutions like Berea College in Kentucky, before his 1917 arrival at Milligan, where he served as president for 23 years. Traveling hundreds of thousands of miles, primarily by train, he raised millions of dollars to assist students with their education.

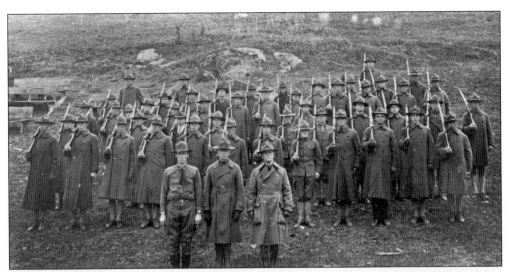

STUDENTS ARMY TRAINING CORPS. As World War I grew in intensity, Milligan administration, faculty, and students committed to service and sacrifice by buying War Savings Stamps, participating in the Red Cross, and hosting this government program for training soldiers to be sent overseas. The trainees lived in the Classroom Building and participated in classes and campus activities. On November 11, 1918, everyone celebrated the war's end, just days before a devastating campus fire.

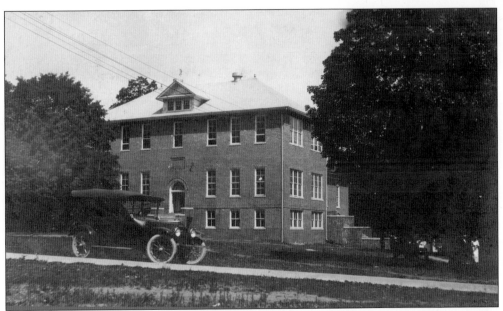

CLASSROOM/ADMINISTRATION BUILDING. On November 16, 1918, the main campus building burned, leaving only Hardin Hall, the president's home, and the powerhouse. Pres. Derthick persisted in collecting insurance from the government for losses during the army's occupancy and raised money to not only replace the old building but to also build Pardee Hall and Cheek Gym. The 1919 classroom/administration building was renovated in 1978 and named in Derthick's honor, then renovated again in 2001.

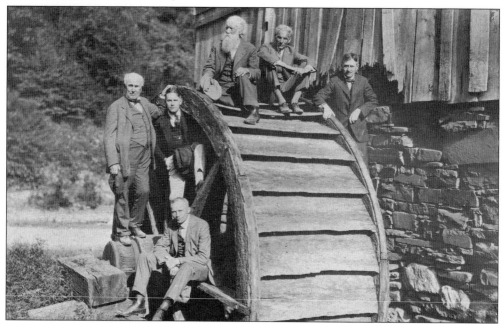

MEN OF INNOVATION, 1918. These men, who called themselves "vagabonds," were photographed en route to a camping trip in the Smoky Mountains. Seated in front is plant pathologist Prof. R.J. DeLoach. Standing from left to right are Thomas Edison, Harvey Firestone Jr., John Burroughs, Henry Ford, and Harvey Firestone Sr. They stopped at Milligan College, and due to President Derthick's contact with Ford, this photograph was sent with a letter on Firestone stationery to President Johnson in 1975.

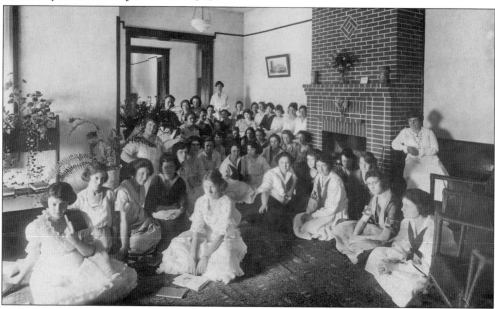

HARDIN HALL PRAYER MEETING, 1920s. First lady Perlea Derthick stands at the back corner during one of the devotions and prayer times she led in the girls' residence hall each evening. She always began by singing "Sweet Hour of Prayer." Regular times of devotions, prayer, and Bible study have remained central to residence life on Milligan's campus.

PARDEE HALL. The new 1919 men's dorm was named for Calvin Pardee, the owner of the Cranberry Iron and Coal Company, who gave $5,000 annually to Milligan for many years. Designed by C.C. Mitchell, it offered parlors, showers, heat, and a head resident's apartment, along with standard rooms for 70 students. The building was located on the lawn across from where the Gregory Center now stands. The foreground tennis courts are now a parking area.

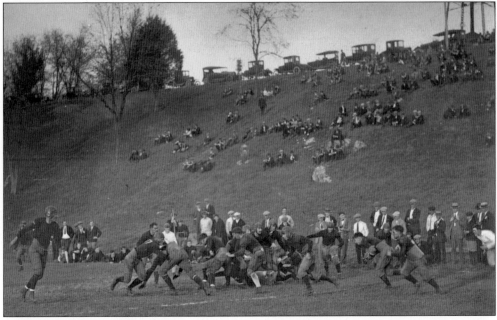

MILLIGAN FOOTBALL, 1920. The first campus football team was started by the Students' Army Training Corps men, and professor Asa Cochrane then formed a prep team. However, the first official team, shown here on the field, was organized after J. Caldwell Wicker became Milligan's athletic director. The team won only two games that year, but quarterback Joe Jared was chosen for the All East Tennessee football squad.

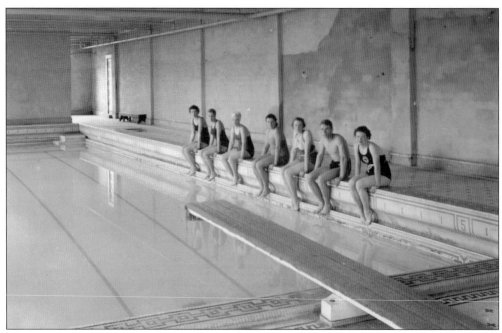

SWIMMING IN CHEEK GYM. The facilities of Cheek Gym, completed in 1924, were unsurpassed in their prime. The building stood behind the present McMahan Student Center and offered a swimming pool, bowling alley, exercise equipment, basketball court and stands, locker rooms, lecture halls, and living quarters. It was named for Joel O. Cheek, a Christian Church member who developed Maxwell House Coffee and became a trustee and devoted Milligan donor. It was demolished in the 1970s.

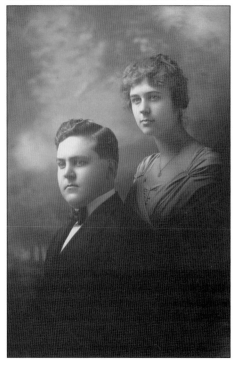

SAM JACK AND MARY THOMAS HYDER. Sam Jack Hyder taught mathematics and was one of Milligan's longest serving and most beloved faculty members. Several acres of campus grounds once belonged to Hyder, who graduated from Milligan in 1916 and married Mary during the intermission of their senior play. He also served as Milligan treasurer and was known for being a good steward of the college. The auditorium of the Science Building was named for him.

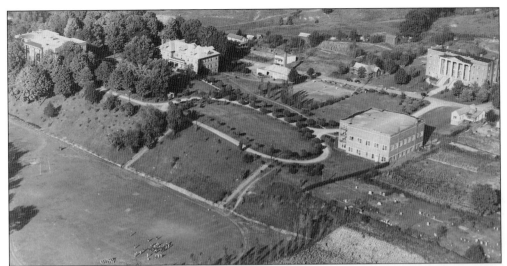

AERIAL VIEW OF CAMPUS. Looking over Anglin Field toward Cheek Gym in the foreground and Pardee Hall in the background to the right, professor Hyder's garden, where the faculty offices were eventually built, is visible beyond the cemetery. Note that behind Hardin Hall is the powerhouse, across from the campus store. The loop drive atop the hill ends where the Science Building later would be constructed.

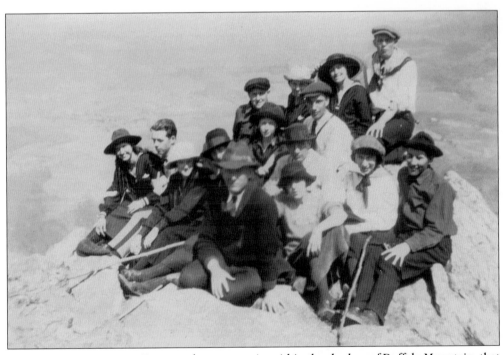

EARLY BUFFALO RAMBLERS. Because the campus sits within the shadow of Buffalo Mountain, that promontory has always been a favorite place from which students have enjoyed the beautiful Appalachian scenery. Exploring the trails there has remained a regular activity of Milligan students, particularly the Buffalo Ramblers hiking and outdoor adventures group.

WIDE HATS AND WIDER SCOPES. After World War I, America entered a golden era, which was also reflected in the styles and activities on campus. Athletic programs and social clubs grew, and under the direction of professor Maurice Bertrand Ingle, the Milligan Bible School Institute was established, offering Christian studies for graduate and undergraduate men and women. Also during this time, the trustee board configuration and the practice of hiring interdenominational instructors were evaluated.

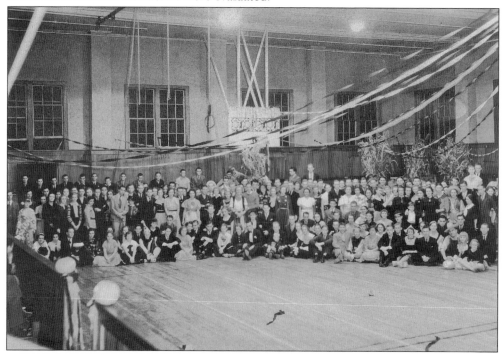

BOY'S PARTY, 1926. Campus social events beyond those offered by various clubs included an annual autumn party, often at Halloween, hosted by the gentlemen and a spring one hosted by the ladies. Historically, Milligan's activities calendar did not include dances, though the Navy V-12 did hold a program-end dance in the Cheek Gym in 1945. Dancing was approved in April 2006, and a Valentine's Day dance was held in 2007.

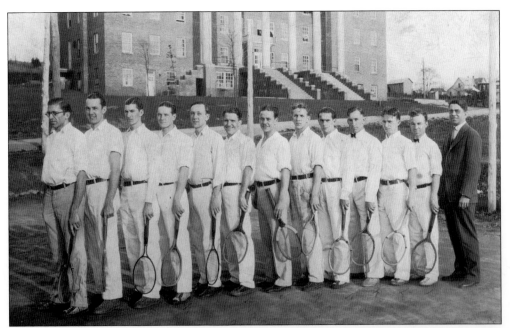

TENNIS TEAM AND PARDEE HALL, 1927. A tennis club was established during the 1914–1915 school year, and courts were built on Anglin Field five years later. However, men's tennis did not become an intercollegiate sport on campus until 1927, when Clement Eyler (shown at far right) was coach. Courts were later established across from the library. In 2005, the W.T. Mathes Tennis Center was dedicated, and the clubhouse was completed in 2010.

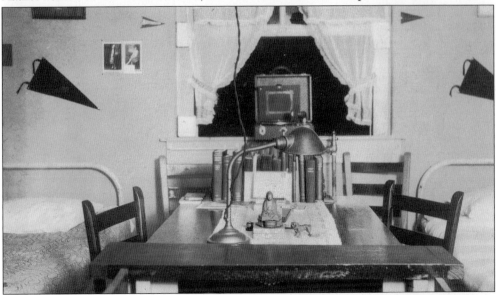

DORM ROOM, 1929. After the 1929 stock market crash and the Great Depression began, Milligan survived via land sales, early retirements, salary cuts, and spending reductions. Although numbers increased in the dorms, students had difficulty paying tuition, so financial assistance was provided through creative work programs as part of Perlea Derthick's landscaping campaign. Milligan served students beyond those in the dorms when evening classes were offered nearby at Elizabethton Junior High School in 1933.

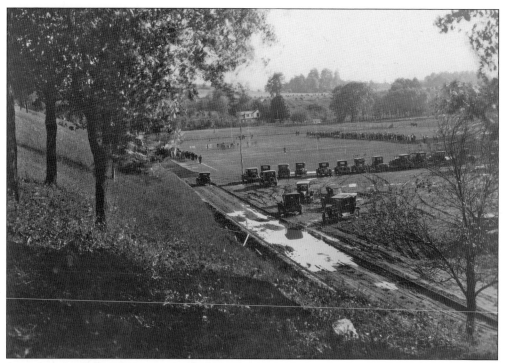

ANGLIN FIELD. William Thomas Anglin was a 1902 graduate who served as an Oklahoma state legislator almost continually from 1918 to 1948. He was speaker of the house in the 1930s. In appreciation for his son's years at Milligan, he donated and raised funds for the athletic track and lighted field, which was then named in his honor. Anglin Field now holds soccer, baseball, and softball fields and a cross-country training loop.

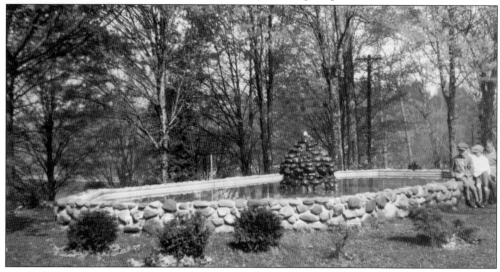

FISH POOL. Perlea Derthick's Milligan the Beautiful effort in the 1930s involved landscaping projects and the construction of enjoyable settings, such as the fish pool, which was located on the lawn in front of Hardin Hall. Because students persisted in adding bubbles to the fountain, it remained drained for a period and was removed in 2001 for the development of the Mary Sword Commons, a beautiful lawn with flower beds.

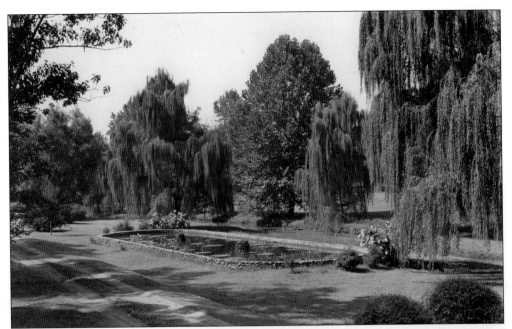

LILY POND, 1930. As part of her efforts to beautify campus, Perlea Derthick had a lily pond built beside Buffalo Creek in the area behind Hopwood Memorial Christian Church. Families picnicked on the grounds, and visitors such as businessman J.C. Penney enjoyed the wide range of ornamental plants. The priority of landscaping continued to be reflected in the beautification projects under the direction of Clarinda Jeanes, who served as the college's first lady from 1997 to 2011, making Milligan an even more picturesque environment.

1930s STUDENTS. Depression era students were frugal but resourceful, forgoing the usual yearbook for much simpler versions, if any at all. The 1935 *Buffalo* was only 20 pages with a felt cover. Students embarked on other ventures, such as printing their own publications with press equipment from E.W. Palmer, president of the Kingsport Press. Archie Grey directed the work. In 1939, radio station WJHL also began broadcasting a regular Milligan radio hour.

SMOKIES TRIP. As the Great Smoky Mountains National Park was being established, annual student trips to see the views became a tradition, and the beauty of the Appalachians was celebrated. Prof. William Augustus Wright wrote in his 1929 poem, "Happy Valley Trail," "I see the peaks of Smoky Mountain Park from where I sit and seem to hear the sound of splashing waters as they fall and then go rushing to fall again . . ."

"TENNESSEE'S FAIR EASTERN MOUNTAINS." The words of Milligan's alma mater by Bela Hubbard Hayden reflect Milligan's sense of place in the beautiful mountain region. Originally named for its proximity to Buffalo Creek and Buffalo Mountain, shown here, the college encourages student appreciation for the area. Visits to additional nearby mountaintops like Holston, Unaka, and Roan, as well as to the Holston, Doe, Nolichucky, and Watauga Rivers and their lakes have continued to inspire students.

CHARLES E. BURNS (1883–1975). Burns served as professor and academic dean two terms at Milligan before his appointment as president in 1940. When the United States entered World War II, college enrollment rapidly declined. Amid economic struggles, Burns turned the college over to the Navy's V-12 program as an act of patriotic assistance but was soon distressed by the circumstances and resigned. He is the only Milligan president buried in the Williams Cemetery on campus.

"HONOR, COURAGE, COMMITMENT." During World War II, the Navy V-12 program brought young men training to become officers to campus, and Milligan became the country's only college completely turned over to the war effort. The 1943 yearbook shows a commando club, organized "to build up the bodies of its members so they will be physically ready when they are called to serve their country." Many alumni from the V-12 program remain staunch Milligan supporters.

THE AFTEREFFECTS OF WAR. When Milligan was reopened to regular students after World War II, Dr. Virgil LeRoy Elliott (1906–1992) was chosen as its president in 1944. He is shown here (left) with Joe McCormick. The GI Bill caused rapid growth in enrollment, and Elliott developed athletic and music programs to increase Milligan's appeal. However, the programs were expensive, so when GI Bill funds ran out, student numbers decreased and the college's debt grew.

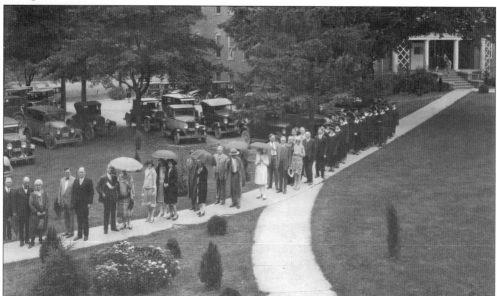

GRADUATION DAY. For many years, commencement ceremonies were held outside on Derthick lawn. In recent decades, services have been held in Seeger Chapel. By tradition, the graduates march from the library to the chapel. They are led by faculty marshals, who are honored senior members of the faculty, and the college's newest professor, who carries a basin and towel, symbolizing the lives of Christian service to which Milligan is dedicated.

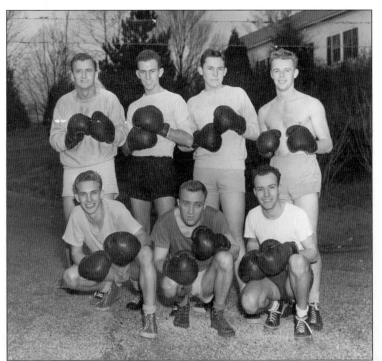

BOXING, 1946. Shown from left to right are (first row) Mainard Campbell, Don Pearce, and Dean Houk; (second row) John Keffer, Bill Lee Smith, James Trollinger, and Clifford Wells. Boxing was offered only as a physical activity and not as a competitive sport. Visible in the background is the Home Economics Cottage, which was located where the McMahan Student Center now stands.

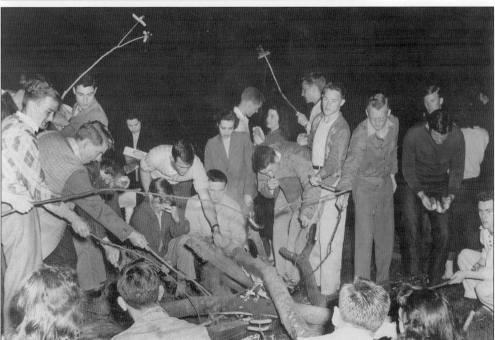

PREMEDICAL CLUB BONFIRE, 1946. In the 1940s, Dean Donald G. Sahli had a reputation for being stern. Upon discovering an unauthorized late-night bonfire and wiener roast (not pictured here), he asked the students who gave permission for the event. One of them replied that he did not realize the wieners needed to give their permission to get roasted. The dean threatened to expel the entire group.

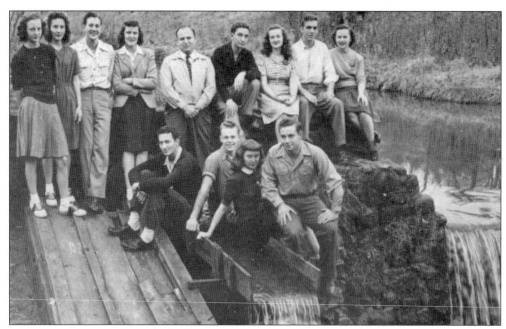

STUDENTS AT WATERWHEEL, 1947. The waterwheel was built on Buffalo Creek at the campus entrance during Perlea Derthick's 1930s Milligan the Beautiful campaign. Shown here are, from left to right, (first row) William Nathaniel Taylor, Clifford Eugene Wells, Peggy Ruth Welsh, and Richard Fred Tucker; (back row) Hattie Anne Wiseman, Gladys Irene Holder, Kenneth Eugene Wilkinson, Margaret Hedy Waechter, Dominic Caruso, Joe Amos Cessna, Gerena Mae Christian, Miller James Packett, and Carolyn Mae Perkins.

RELATIONSHIPS. Students of the 1940s reflected the nation's postwar relief and eagerness for fun. Campus activities offered many opportunities for making memories and establishing relationships. Even though Milligan had no women's intercollegiate athletic programs at the time, physical fitness activities were enjoyed by all, and campus spirit was fanned by the football program.

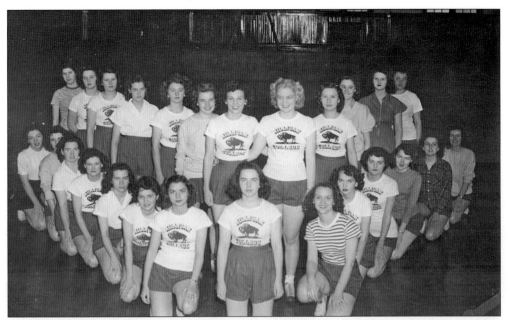

WOMEN'S ATHLETICS. The athletics program included the women's athletic association, which offered archery, tennis, shuffleboard, swimming, and bowling. Beyond the usual organized intramural athletics in sports such as volleyball and flag football, more recent recreational activities have included skiing, horseback riding, scuba diving, and ultimate frisbee.

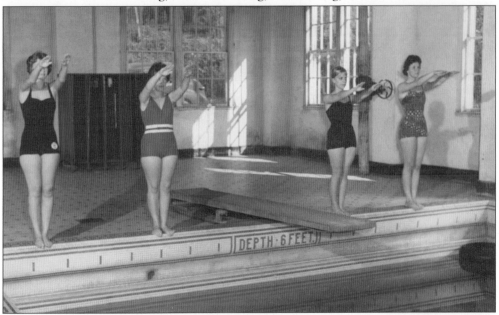

SWIMMING, 1948. Milligan's Cheek Gym had a pool and a Water Buffaloes swimming club, but swimmers now utilize the 25-meter pool in the Steve Lacy Fieldhouse. From 1977 to 1986, the club competed against other clubs and intercollegiate teams and enjoyed much success under the leadership of coach Chuck Gee. Milligan's intercollegiate program did not begin until 2007, but in their first year of regular collegiate competition, the Milligan Aqua Buffs finished 22nd overall nationally.

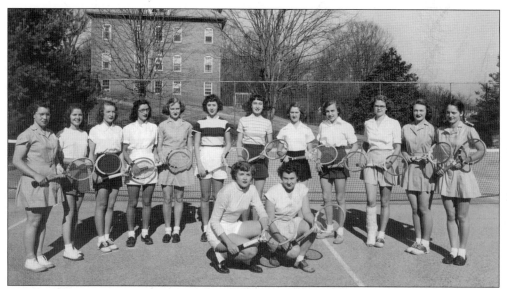

WOMEN'S TENNIS, 1949. Established during the 1914–1915 school year, Milligan's tennis club had courts in 1921, but intercollegiate (men's) competition did not begin until 1927. The program grew under coach Hugh Thompson, professor of chemistry and physics, and continued under coach Constance Mynatt. Now considered an Appalachian Athletic Conference powerhouse, the Lady Buffs have won several conference championships and made multiple trips to the NAIA Region XII National Championship, which they hosted in 2008.

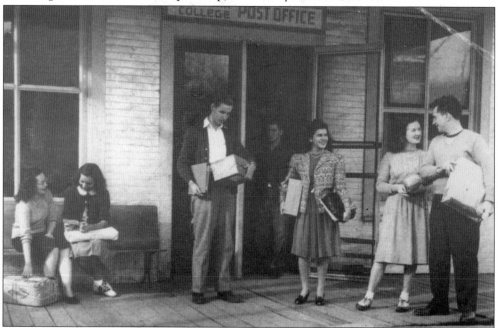

MILLIGAN COLLEGE POST OFFICE, 1948. Originally Cave Spring, the post office was changed to simply "Milligan" in 1882, the same year the Buffalo Institute was chartered as Milligan College. The post office name was later changed to Milligan College at the request of Robert Milligan's son, Alexander Milligan, in 1909. In the 1950s, postmaster Cad Price took Milligan mail by wheelbarrow to the depot near Happy Valley School.

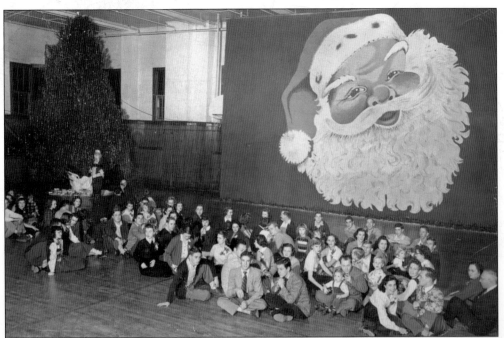

CHRISTMAS PARTY, 1948. This photograph shows when all Milligan groups joined in the gymnasium to host a Christmas party, the first of its kind on campus. The large Santa was painted by a student, art editor Randy Cooper, who used Kem-Tone, a Sherwin Williams water-based paint product developed when linseed oil was rationed during World War II. The washable paint surface revolutionized household painting and allowed the Santa backdrop to be used repeatedly.

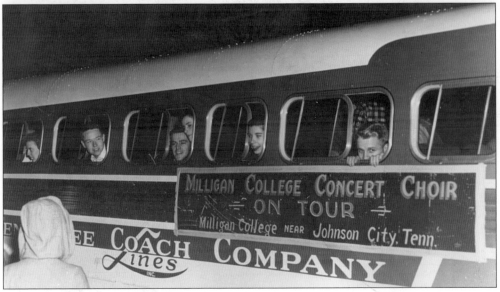

CHOIR BUS TOUR, 1948. The Florida trip covered 2,000 miles and included a brief message from dean of women Mildred Welshimer at each church where they sang. The group was directed by Gordon and Georgette Warner. The concert choir continued to enjoy annual tours throughout the United States, performing at churches, schools, and conventions.

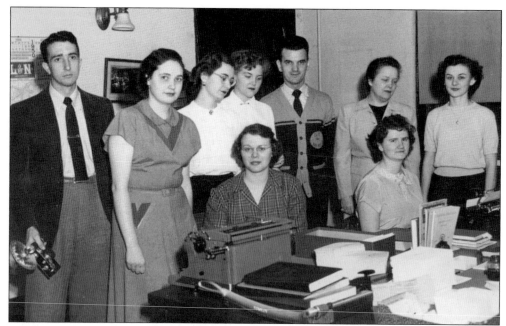

STAMPEDE STAFF, 1950. The student newspaper name was changed from the *Trident* to the *Stampede* in 1926, and the publication continued to serve the campus with the latest news and commentary. The alumni paper, the *Milligan Alumnus*, was established in 1928, eventually transforming into the *Mill-Agenda*, and then later becoming the high-quality *Milligan Magazine*, published since 1999.

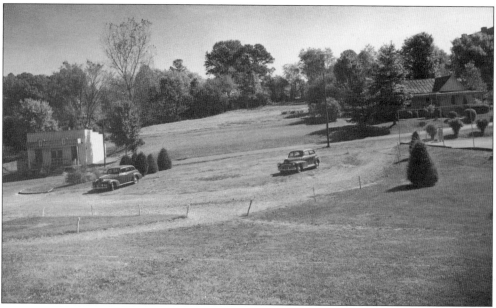

MILLIGAN STORE (LEFT), 1950. Students have enjoyed several campus stores throughout the years, and the offered goods and services have included everything from the standard books and supplies to food and laundry. This scene also shows Wolfe Hall on the right, Pardee Hall at upper right, and evidence of where the Johnson City bus circled the parking lot next to the tennis courts.

HALLOWEEN PARTY. These students are enjoying the traditional campus party that began in 1921 and was originally held in Pardee Hall, then was moved to Cheek Hall Gym in 1932. More recently, the Halloween tradition has consisted of a Trunk or Treat event, where students decorate their vehicles in the parking lot commonly referred to as "the canyon" and distribute candy to area children.

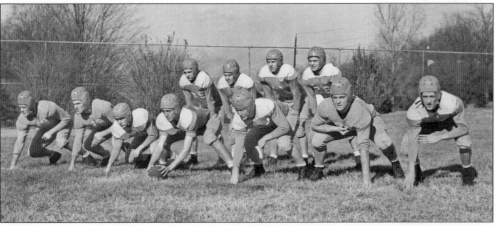

"UNDEFEATED SINCE 1950." Milligan's football program won multiple Smoky Mountain Conference championships and produced several All-Conference players. The 1940 team was undefeated. In a 1940s Burley Bowl, Milligan lost to highly favored Southeastern Louisiana College by a mere 21-13. Although the football program enjoyed success and popularity during its 30 years (even playing teams such as Duke and the University of Tennessee), it was dropped from Milligan athletics in 1950 for financial reasons.

Dr. Dean Everest Walker (1899–1988). Dr. Walker (shown above at pulpit in Hopwood Memorial Christian Church on campus and in the portrait below) became Milligan's president in 1950, a short time after Dr. Elliott's departure. Walker believed in the philosophy that "all knowledge is one" and developed the use of academic areas of learning that are still used today. Emmanuel School of Religion (now Emmanuel Christian Seminary) was founded under his leadership, and Milligan grew in many ways. In 1968, he stepped down from the presidency and was appointed as chancellor of Milligan, a capacity he filled for 20 years. He also continued to have great influence within the various organizations and memberships of the Christian Churches throughout his life.

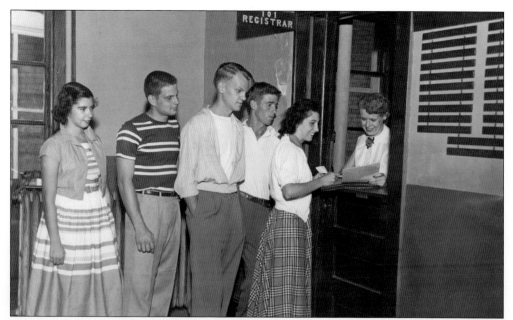

REGISTRATION IN THE ADMINISTRATION BUILDING, 1950. Built in 1919 and called the new Classroom Building (now Derthick Hall), it continues to serve as home to many classes and academic offices, such as that of the registrar. Technology has changed the registration process shown in this setting with registrar Lois Hale, allowing greater convenience for students, faculty, and longtime registrars Phyllis Fontaine and Sue Skidmore. However, Milligan students continue to enjoy personal attention from faculty and staff.

THE M CLUB. Created in the 1924–1925 school year as a letterman's organization with Phil Sawyer, Joe McCormick, and Charles Crouch as officers, membership initially required having earned a varsity letter in football, basketball, or baseball. High school letters were discouraged from being worn on campus. A women's M Club was also soon established as women's athletic opportunities grew.

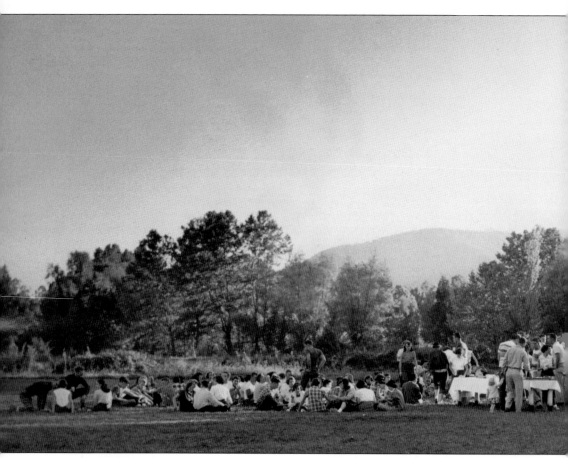

PICNIC ON ANGLIN FIELD. This scene reflects the type of fellowship that is part of the Milligan tradition. In addition to an annual picnic for graduating seniors to celebrate with faculty and staff, residence life activities include those planned by the Campus Activities Board for all students, as well as events sponsored by various clubs and organizations. The Campus Ministry Team, too, has representatives from groups like Fellowship of Christian Athletes,

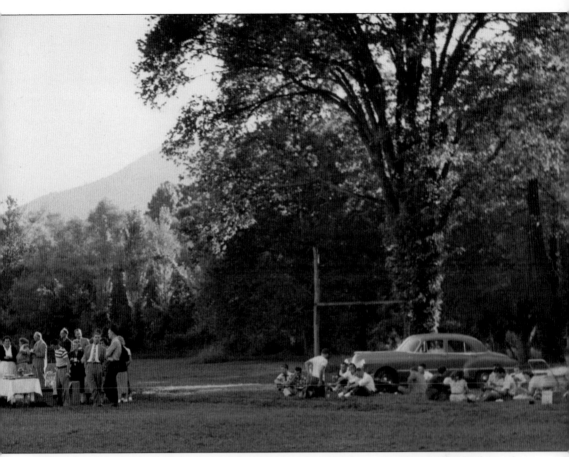

Vespers, Cross Cultural Missions Committee, Service Seekers, Linking Individuals to the Needs of the Community, Habitat for Humanity, and Campus Ministry Committee that hold opportunities for fellowship. The faculty and staff offer family-style gatherings as well, in the form of dinners, cookouts, Bible studies, and various other meetings on campus and at their homes.

MUSIC APPRECIATION, 1951. Though the mode of delivery has changed since these students enjoyed sampling various genres, the importance of music in the Milligan liberal arts experience has remained. The humanities program, established in the 1960s, is distinctive to the Milligan curriculum, which integrates music, literature, art, and philosophy into the study of broader achievements throughout history.

PREMEDICAL CLUB, 1952. Formed in 1926, the group stayed active across the decades. Milligan has continued to equip students for success in medical school and careers in related medical fields. Its nursing program, begun in 1992, has consistently graduated classes with stellar exam records and employment placement. Dual degree and affiliation agreements often allow students to complete a bachelor's degree at Milligan and a subsequent doctorate at participating pharmacy colleges within seven years.

STUDENT UNION BUILDING (SUB). In 1951, Milligan students launched their own building campaign to erect a structure that would house a bookstore, soda fountain, snack bar, lounge, and game room. Led by T.P. Jones and Randy Cooper, they raised $15,000 and did some of the construction themselves. It was managed by Roscoe (also known as "Pop") and Geneva Shepherd, previous managers of the campus store, a frame building that stood in the area of the Welshimer Library driveway.

PROFESSOR OAKES HELPS BUILD THE SUB FOUNDATION. Prof. Guy Oakes served as academic dean in the 1960s during initiation of the honors program, which later gave rise to the humanities program. The humanities program is a four-semester experience for freshman and sophomores. Rather than viewing academic subjects as discrete and unrelated disciplines, the program takes an integrated perspective viewing history, arts, literature, philosophy, and the Creator of all these disciplines.

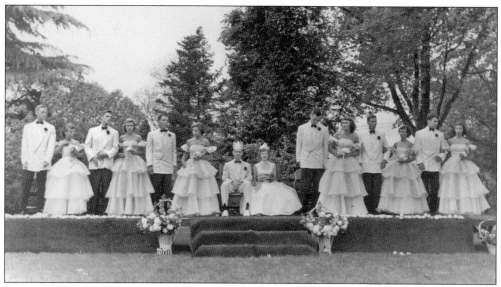

MAY DAY, 1952. The court participants are, from left to right, Sam Greer, Sally Bonner, Amon McSwords, Louise Spurgin, Kara Bright, Carolyn Story, John Ammerman, Ruth Brown, Randy Cooper, Sally Bellamy, Randy Lyons, Jean Ball, Pat Hand, and Alice McDonald. The event was a campus tradition for decades.

PHYSICAL EDUCATION CLUB. This 1951–1952 membership is a sampling of an organization with a long campus history. Other clubs from throughout the decades included the Piano Club, the Girls Missionary Circle, and the Latin Club of the 1920s; the Glee Club, Camera Club, Life Saving Corps, and German Club from the 1930s; and Christian Endeavor, the Forum Club, and the International Relations Club during the World War II years of the 1940s.

ENJOYING THE WEATHER, 1952. Students attending Milligan appreciate the benefits of experiencing the four seasons. Besides the flowering trees of spring, warm summer temperatures, and colorful fall foliage, the winters usually offer at least a couple of snowfalls significant enough for sledding and the fun shown here, enjoyed by, from left to right, unidentified, Bill Casteel, Pat Hand, unidentified, Alice McDonald, and Betty Jean Masters.

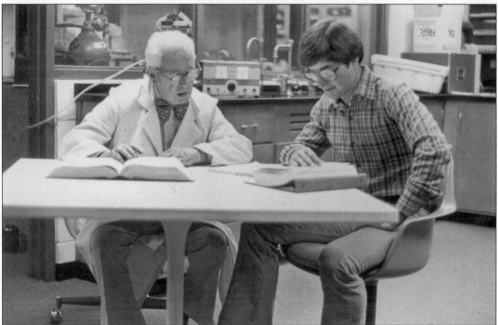

PROF. LONE L. SISK. Professor Sisk, seated at left, taught chemistry, beginning in 1948, and lovingly referred to his students as "dear hearts." He received the Fide et Amore Distinguished Service Citation when it was first awarded in 1972. The college's highest honor, the award is given to recognize faithful and loving service to the college. It reflects Milligan's motto, *"age deo fide et amore,"* which translates as, "go with God in faith and love."

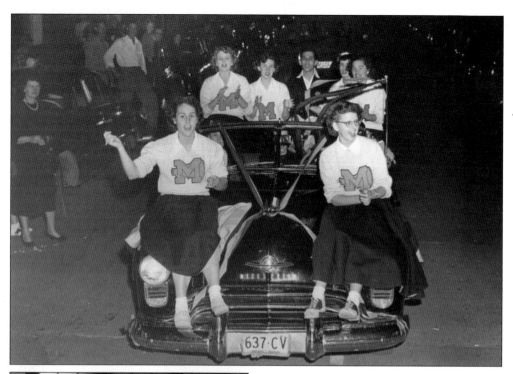

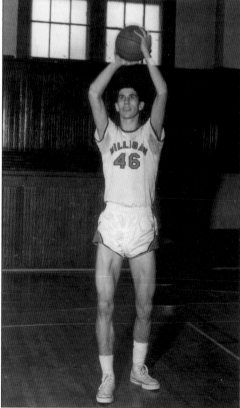

CHEERLEADERS. Like these from the 1950s, Milligan's cheerleaders remain a coed squad, and they cheer for men's and women's basketball. This athletic organization is coached by Ronda Paulson, who, aided by Jennifer Greenwell and choreographer Macy Garland, also began a competitive dance program in the fall of 2010. Established to support school spirit, the dance team became part of Milligan's intercollegiate athletic programs that compete in the Appalachian Athletic Conference and National Association of Intercollegiate Athletics.

MEN'S BASKETBALL. Milligan's basketball legacy includes many Smoky Mountain Conference Championships and two 1958 graduates: Del Harris (shown), a National Basketball Association coach with more than 500 wins, and Sonny Smith, a popular television commentator and legendary collegiate coach. The 1999 team set an Appalachian Athletic Conference record with a 21-0 season and a total of 29 wins. Coaches Clement Eyler, Duard Walker, and Tony Wallingford helped establish Milligan's impressive basketball reputation.

INSIDE HARDIN HALL. In 1913, Hardin Hall was constructed as a women's dormitory and also housed the dean of women and other female faculty. From the 1920s to 1957, the facility also housed the college's kitchen and dining hall. The lower level was used as administrative and faculty offices in the 1960s until the entire facility was renovated in 1992 to house the Arnold Nursing Science Center and the Wilson Lecture Hall.

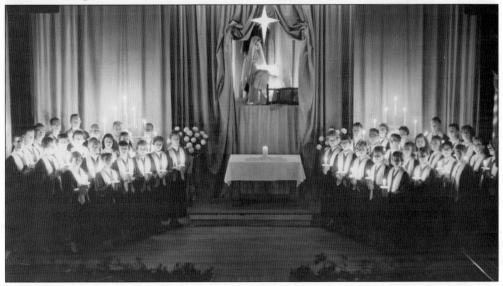

FEAST OF LIGHTS CHRISTMAS PROGRAM. The Milligan College Concert Choir was directed by Ruth White from 1951 to 1957. Under her influence, the music and theater programs at Milligan made great strides. White also took leadership in organizing campus events, such as Founders Day, in which the choir regularly performed. In addition to her academic duties, White enjoyed a semiprofessional singing career and performed throughout the area.

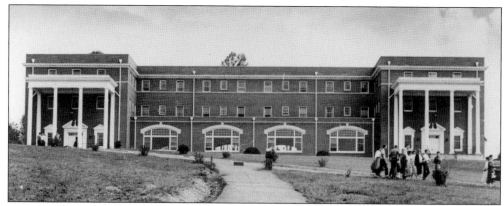

SUTTON MEMORIAL HALL. Dedicated in 1956, its residence floors have 30 suites. The building also contains the Mabel Stephens Annex and the main campus kitchen, as well as the Joe and Lora McCormick Dining Center, which seats about 300. The structure was made possible by the generosity of Webb and Nanye Bishop Sutton. Webb Sutton was founder and president of Sutton Construction Company of Richmond, Virginia.

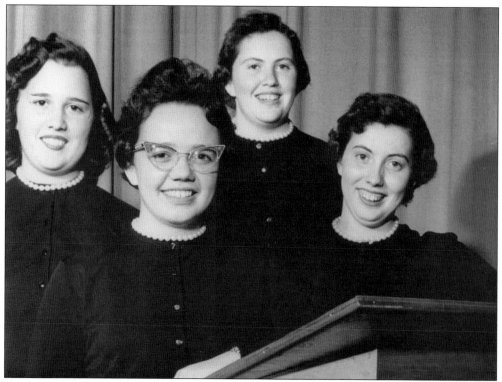

HARMONETTES, 1957. This student singing group included Judy Pease, Lynn Fowler, and Janet Matthews, with Frances Matthews as accompanist. Other ensembles from former years included the Millitones, Volunteers, Keynotes, Christian Heirs, Co-Eds, and Messengers. Milligan music graduates teach at all levels of music education, serve in music ministry positions, conduct professional music organizations, teach studio music, and perform professionally.

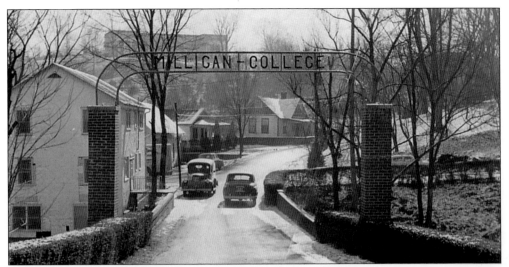

CAMPUS ENTRANCE. The class of 1958 provided Milligan an iron archway. Other entrance improvements had included the renovation of the old post office, which was then also used as apartments and faculty offices. Administrator Joe McCormick helped brothers Prof. Owen L. Crouch and Joe Crouch with funding for the project, and they named it the Crouch Memorial Building in honor of their parents, William Peyton (class of 1905 and trustee) and Frankie (Tuttle) Crouch.

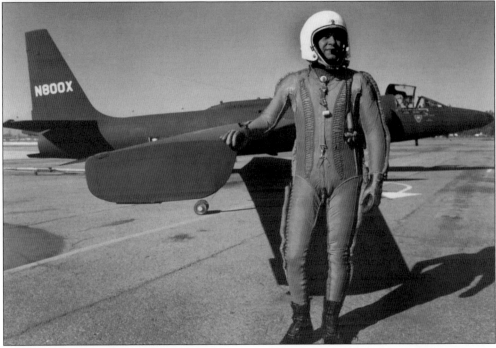

A SPY IN THE COLD WAR. Milligan 1950 graduate Francis Gary Powers was convicted by the Soviet Union as an American spy after his U-2 reconnaissance plane was shot down, placing him in the international spotlight. He was held in Vladimir Prison for 17 months before his release in 1962 as part of a prisoner exchange. Though the incident sparked great controversy, Powers received several honors. A 1976 movie starring Lee Majors tells the story.

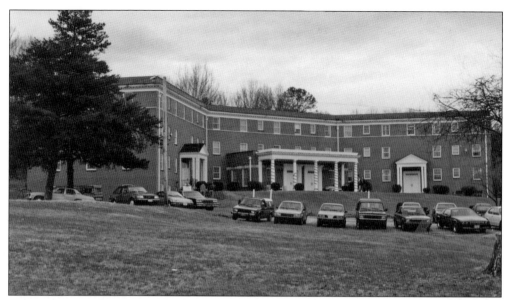

WEBB MEMORIAL HALL. Completed in January 1960, the 170-plus occupancy residence hall was a gift of Nanye Bishop Sutton, a member of the class of 1900, in memory of her husband, Webb. Nanye Sutton also provided much of the funds for Sutton Hall, and the Sutton family is counted among Milligan's strong supporters.

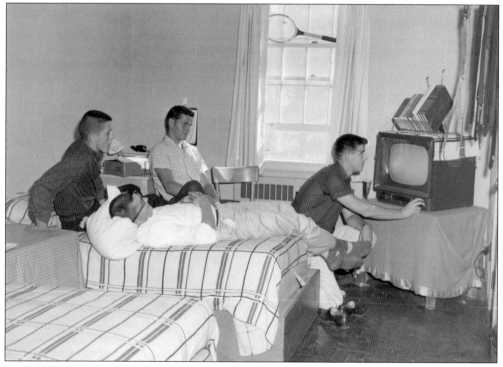

DORM LIFE IN THE 1960s. Complete with the modern convenience of television, the residence hall room these young men shared also had desks, beds, and access to a bathroom. However, student housing at Milligan first began in the 1800s as rooms within the homes of faculty and administrators, and two 6-hole outhouses were the early restroom facilities on campus.

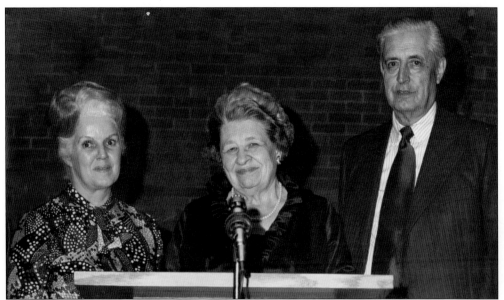

WELSHIMERS AND THE LIBRARY. Mildred Welshimer (above, center) joined the faculty in 1947 and served as dean of women. She later married former Milligan trustee Benjamin Dwight "B.D." Phillips. Her father, Pearl Howard "P.H." Welshimer, was a Restoration Movement leader. After her father's death, Mildred's gift of his 7,000 volume library and that of her deceased sister, Helen, significantly increased Milligan's collection and necessitated a welcomed new building (shown under construction below). The 1961 three-floor library bearing his name was the gift of the T.W. Phillips Jr. Charitable Trust and the Phillips family of Butler, Pennsylvania, after an initial gift by the Kresge Foundation of Detroit, Michigan. The building keystones, illustrating revelation, creativity, government, letters and philosophy, and science, also reflect Milligan's commitment to the liberal arts. To move the books from the Administration Building library to their new home, students formed a book brigade and, within two hours, passed them hand to hand, setting them up on the new library's shelves.

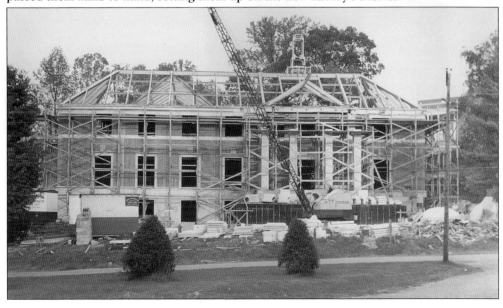

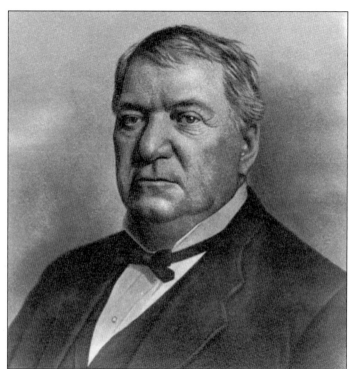

A Faithful Family.
T.W. Phillips Sr. (1835–1912), shown here, was the progenitor of several faithful Milligan supporters. The generosity of the Phillips family is evident throughout the Milligan campus. Contributions from B.D. and Mildred (Welshimer) Phillips, the B.D. Phillips Charitable Trust, the T.W. Phillips Jr. Charitable Trust, and other members of the Phillips family are manifested in the P.H. Welshimer Memorial Library, Seeger Chapel, Steve Lacy Fieldhouse, and the Taylor-Phillips House.

Ivor Gwendolyn Jones. Ivor Jones, Milligan class of 1926, was a longtime professor of history and also served as dean of women at the college. The Ivor Jones Outstanding Senior Award is the highest award given to a graduating student. The 1962 annual is dedicated to Jones, and she received a Fide Et Amore award in 1979. Her sister Juanita M. Jones was a faculty member in the English department.

ORVEL C. CROWDER. Dr. Crowder earned his doctorate from Harvard Divinity School and was an honor student of noted theologian Paul Tillich. Crowder taught psychology at Milligan from 1957 to 1982 and served as senior minister at Hopwood Christian Church throughout the same period. During 10 of those years, he also coached the Milligan wrestling team. A champion wrestler from World War II, he was inducted into the Milligan Athletic Hall of Fame in 1996.

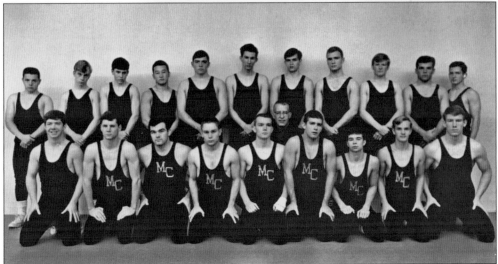

WRESTLING. In 1961, Orvel Crowder, shown at center, began coaching a Milligan wrestling team, which competed with the larger universities in the Southeastern Wrestling Conference. Gordon Perry, Sam Bower, Rex Jackson (shown third from left), and Pete Beevers were outstanding mat men of this era.

GOLF. In the spring of 1962, coach Ray Stahl established a golf program as an intercollegiate sport at Milligan, and the team won the Eastern Division championship of the Volunteer State Athletic Conference that first season. In recent years under coach Tony Wallingford, the men's teams have captured three conference championships, one regional title, and, in 2007, their first ever national championship appearance. A women's program was added in 2010.

RAY E. STAHL SR. Dr. Stahl served Milligan as a student recruiter, business manager, and in public relations. Stahl is credited with being instrumental in keeping the college afloat in dire financial times. A former residence hall, Stahl Hall, which had previously been the home of Stahl and his wife, Faith, was razed to make way for Webb Hall. A local historian, Stahl authored the book *Greater Johnson City: A Pictorial History.*

"MA AND PA" HELSABECK. Eleanor "Cookie" Helsabeck began serving at Milligan in 1960, first as head housemother at Pardee Hall and later as receptionist to the president. Her husband, W. Dennis Helsabeck Sr., taught counseling at Milligan from 1963 until 1979. For many years, every senior was invited to dinner at the Helsabeck home. Their son Dennis Jr. came to Milligan in 1981 and was professor of history until his retirement from full-time teaching in 2007.

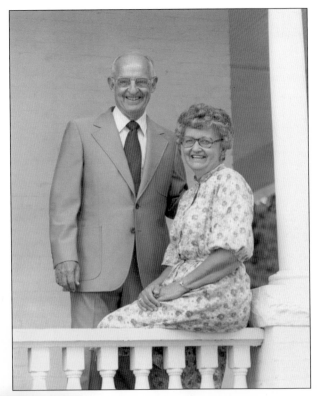

HENRY WEBB. Dr. Webb joined the Milligan faculty in 1950. He was the first holder of the Dean E. Walker Chair of Church History and led the early humanities tours. The Henry and Emerald Webb Chair of History and the Henry and Emerald Webb Christian Unity lectureship are named for him and his wife. He is the author of works that include *In Search of Christian Unity: A History of the Restoration Movement* and *Deacons: Servant Models of the Church*.

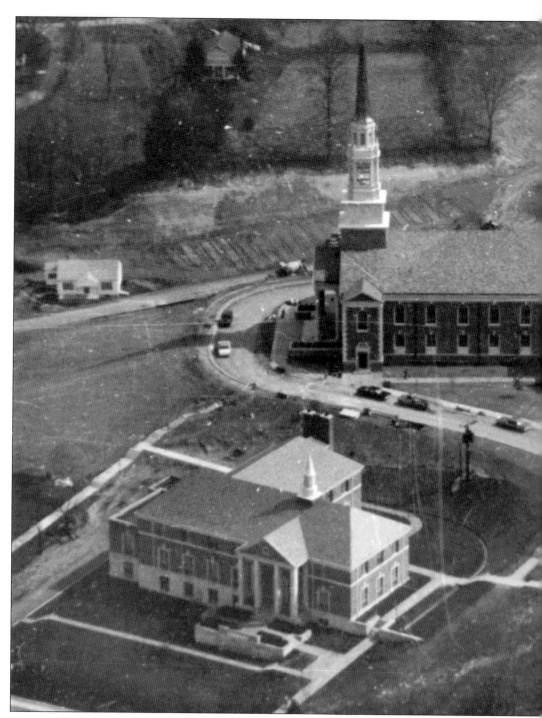

AERIAL VIEW OF SEEGER CHAPEL, 1967. Built with faith and financial optimism on the former campus dump site in the mid-1960s, Seeger Chapel's construction debt was finally retired in 1990. In 2011, the auditorium was updated through a gift honoring local arts patron Mary B. Martin. Seeger serves physically and spiritually as the heart of Milligan College, with its 170-foot spire topped by a 12-foot Celtic cross, the highest point on campus. The Celtic cross is

also part of Milligan's logo. Milligan's mission and vision of honoring God by educating men and women to be servant leaders is evident in its publications, where student testimonies of their Milligan experiences are often shared. Telling the Milligan story is overseen by the area of enrollment management and marketing, whose efforts, under the leadership of Vice Pres. Lee Fierbaugh, helped set an enrollment record of 1,100 students in 2010.

SEEGER STAINED GLASS WINDOWS. Designed and fabricated by Gordon Smith, shown here, the upper windows portray events from the Old Testament (east wall) and the New Testament (west), while the lower level depicts each of the 12 Apostles. Additional windows in the stairwells and above the doors show events in the lives of Moses, Paul, and Christ. Even the borders and glass colors reflect meaningful symbolism from the story of Christian faith.

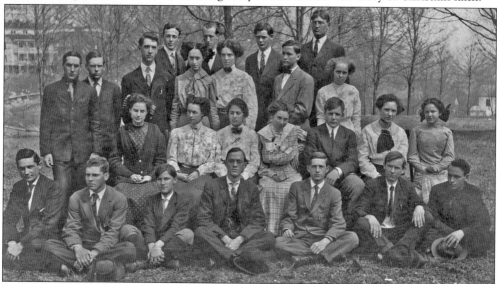

FRANK H. KNIGHT. Knight, standing second from left in this 1909–1910 mathematics class, was an important economist of the 20th century. A 1911 alum, he later earned his doctorate from Cornell University. His classic book, *Risk, Uncertainty, and Profit*, resulted from his doctoral dissertation. Knight was head of the Department of Economics at the University of Chicago from the 1920s to the early 1960s, during which time one of his star pupils was Milton Friedman.

EUGENE P. PRICE. Professor Price served as a business faculty member from 1949 to 1994. The Eugene P. Price Business Complex in Hardin Hall was named for him. In 1998, part of the area was renovated to house the McGlothlin-Street Occupational Therapy Center. For the college's centennial celebration in 1981, Price's wife, Edyth, designed a commemorative seal, which states, "Christian Education—Heritage of the Past—Hope for the Future."

TEN-YEAR PLAN. Dr. Jess Walter Johnson (1917–2008) began at Milligan as vice president for development when the position was created in 1966, and he became president in 1968. His 13-year tenure was marked by several building projects and expansions, but the college also faced many challenges, including a decline in the national student population. Following his presidency, he became Milligan's chancellor and then continued in ministry and fund raising after his retirement.

PHYLLIS FONTAINE. Fontaine served as the college's registrar from 1963 to 1991. She was well loved by the students, who remember her as a voice of reason and fairness and a good listener who knew them by name. Upon retirement, she was awarded the Fide et Amore award for dedicated service to the college. Her father, Joe Dampier, was one of the founders of Emmanuel School of Religion.

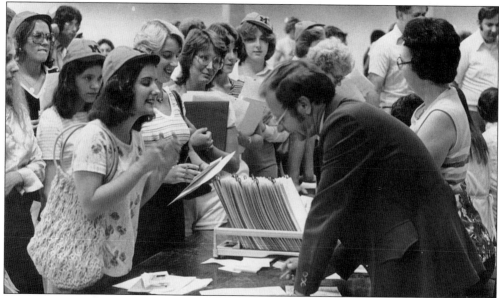

"DINKS." This photograph of a registration day shows a 50-plus-year tradition of freshmen wearing orange and black beanies, or dinks, the first week of school or until the football team won its first game. Freshmen caught without their dinks were subjected to kangaroo court or tossed into the creek. The dink tradition ended in the early 1990s in accordance with federal hazing laws.

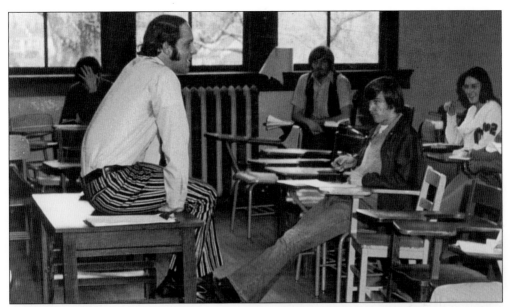

CLASSROOM, 1970s. As baby boomers aged beyond the college years and national college enrollment dwindled, students of the 1970s had a different mindset, having come of age during the Cold War and Vietnam War. The humanities program helped meet some of the intellectual needs of their restless minds. They also enjoyed the new state-of-the-art science building and its laboratories at a time when the nation was consumed with scientific advancements.

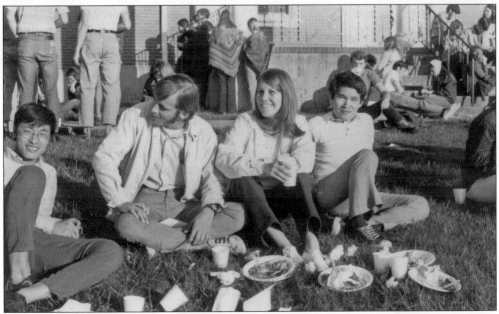

FELLOWSHIP. Annual picnics and other similar events have always been a Milligan tradition, allowing faculty, staff, and students to socialize outside the classroom and campus offices. The cafeteria, updated in 2007 with booths, high tables, and special food service options, also provides a great place for mingling and conversation. Because knowing others as individuals and establishing meaningful relationships are important to the Milligan campus family, opportunities for fellowship are high priority.

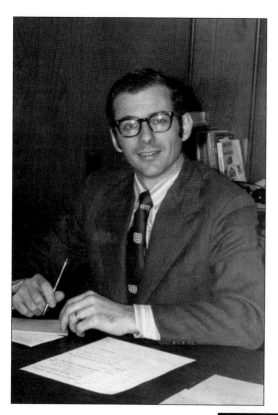

Dr. E. LeRoy Lawson. Dr. Lawson served Milligan from 1965 to 1973 as English professor, humanities program director, and vice president. Subsequently, Dr. Lawson served as senior minister at Central Christian Church in Mesa, Arizona, president of Hope International University, and as consultant to Christian Missionary Fellowship International. A Milligan humanities program founder, he returned for a semester in 2010 to once again teach how the arts speak of God's work in the world.

Dr. C. Robert Wetzel. Milligan professor of philosophy and academic dean Bob Wetzel later served as president of Emmanuel School of Religion. After retiring, as a creator of Milligan's humanities program, he returned for Fall 2010 to again teach it, saying it presents a "worldview in which the Bible is not just over here and history is over there, but rather, this is how God is working and really does have something to do with historical development."

WALLACE AND LURA BARF TRIPS.
Biology professor Dr. Gary Wallace
(shown here) and chemistry
professor Dr. Richard Lura are
known for their discovery learning
opportunities offered outside of
the classroom. They are often
remembered for the "Birds and
Aquatic mammals Research Foray"
(BARF) trips, where their often-
seasick students sailed the Atlantic to
study ocean life. Retired professors
Gene Nix, David A. Roberts, and
Julia Wade were also longtime
science faculty committed to
teaching excellence.

DR. CHARLES W. GEE. Professor Gee first began teaching biology at Milligan in 1967, and he did so for 31 years. He was awarded the Sears-Roebuck Foundation Teaching Excellence and Campus Leadership Award in 1990 and the Faculty Appreciation Award in 1997. With the addition of the master of occupational therapy degree in 1998, the college renovated laboratories in the science building and constructed a new gross anatomy lab, which was name for Gee.

B. Harold Stout. Stout graduated from nearby East Tennessee State University in 1956. Two years later, he began a 24-year stint at Milligan, during which he served as professor, coach, and athletic director. Coach Stout's baseball teams finished first or second in the Volunteer State Athletic Conference 11 times. He was conference coach of the year nine times. Stout was inducted into the National Association of Intercollegiate Athletics Hall of Fame in 1987.

Dan Carroll on the Track, 1973. Begun in 1916 after the Hopwoods returned for a second term, track enjoyed revitalization in the 1940s. In 1968, nine Milligan relay runners ran two-mile stretches from Knoxville to Milligan, covering 110 miles in 12 hours to promote the sport. Milligan track athlete Dan Carroll, a 1975 graduate, became an Iowa state representative and also served as assistant house majority leader.

RESTING ON THE PREMISES. Kevin Harkey, now assistant to the president, is shown as a Milligan student before his 1973 graduation, succumbed to his late-night studies related to the Christ in Culture class. Considered the senior capstone course for all students and taught at that time by Dr. Richard Phillips, Christ in Culture is an examination of how Western societies have shaped the Christian perspective and how Christians might respond to cultural challenges today.

LOIS HALE. Hale was a 1928 alumna of Milligan and later became professor of English at the institution. She recalled the strict rules of her student days and recounted that every week during study hours, the girls' boyfriends would bring ice cream from Shupes, the campus store, to their dorm windows. The girls would lower a bucket by rope so the ice cream could be obtained and enjoyed.

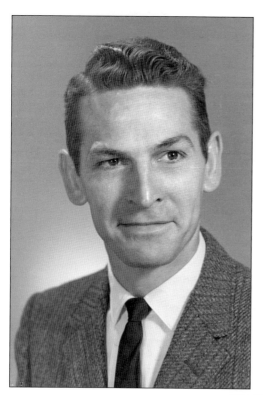

ROY HAMPTON. Hampton received his undergraduate degree from Milligan in 1949. Having proven himself to be an outstanding athlete and strong scholar, he would later return to Milligan as a professor and campus minister at the Collegiate Church, which met in Seeger Chapel and continued until the late 1970s. Other ministers of the Collegiate Church were Robert Dennison, Robert Fife, and Henry Webb.

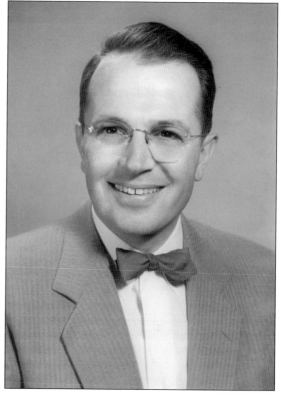

DR. ROBERT OLDHAM FIFE. Bob Fife taught history at Milligan College and Emmanuel School of Religion. Fife strongly advocated for unity during the period of division between the Christian Church (Disciples of Christ) and the Christian Churches/Churches of Christ. Fife took the side of neither a denominational nor a strict Congregationalist structure.

MILLIGAN ARCH, 1974. James Schneider is shown beside the lighted arch, funded by John and Pearl Hart to honor John's sister, Susan "Dimple" Hart Christian (who taught expression and speech classes from 1924 to 1939), as well as Willis Baxter Boyd (who was dean and professor of education and philosophy from 1914 to 1926) and his wife, Nan (who served as librarian and for whom John Hart was a student worker).

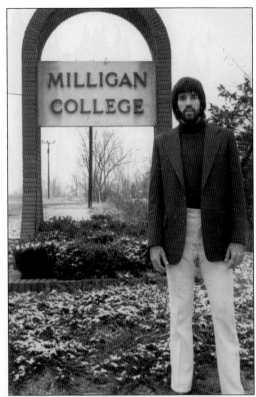

PERFORMING ARTS. With the initial influence of early speech teacher Susan Hart and the continued leadership of theater professors such as Richard Major, who became a faculty member in 1985, the thriving theater program well serves the campus and community. In addition to 1970s opportunities like the madrigal dinners, the performing arts students, such as those in the concert choir, were showcased at larger events like Pres. Richard Nixon's National Prayer Breakfast.

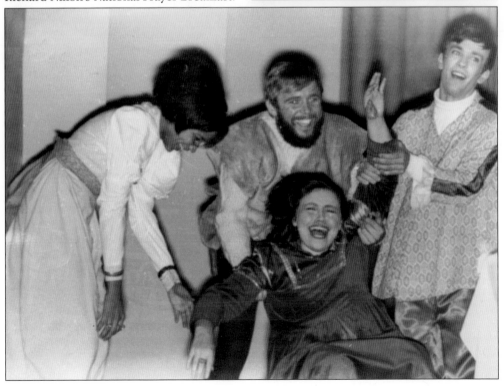

GARY RICHARDSON. A 1978 graduate, Richardson is perhaps best known for coauthoring *The Rock and the Rabbi*, a musical about Peter and Jesus set in contemporary style. Richardson wrote the script, and Danny Hamilton wrote the music and lyrics. The first part of a trilogy, the show debuted in 1998 in Clearwater, Florida. The program has since been performed throughout the nation, including several performances at Milligan and nearby Barter Theatre.

DOWNHILL. Danny Carroll (front) and Rob Hooker take a wagon ride down Seeger Hill. Both survived to become fine upstanding citizens. Carroll is now speaker pro tempore of the Iowa House of Representatives and director of community relations for Iowa Telecom. Hooker is superintendent of schools in Scottsburg, Indiana. They are also both proud parents of Milligan alumni.

Four

FORWARD EVER
AND THE FUTURE

LEGGETT LEGACY. Shown with actor Don Knotts (center), Dr. Marshall James Leggett (born 1929) and his wife, Jean (Fritz), enjoyed life at Milligan. A 1951 alum and Christian Church minister, he served as president from 1982 to 1997. His term brought development of a new student center, an athletic complex, residence halls, land acquisitions, and nursing, occupational therapy, and degree completion programs. Academics were strengthened, enrollment increased, and finances improved during his presidency.

BUFFALO FANS. In the shadow of Buffalo Mountain, along Buffalo Creek, Milligan in 1921 chose naturally to have the buffalo as its mascot. Also referred to as "buffs" and the "herd," students have enjoyed pranks of placing the college mascot, in all its various forms, in some most unlikely places. It has appeared in the chapel bell tower, in places such as the

administrators' offices and atop buildings, and has been known to travel off campus. The school colors are orange and black. Milligan's school spirit is also boosted by the Fanatics, a student group that promotes unity in support of athletics and residence life activities through campus and community involvement.

COACH DUARD WALKER. Walker attended Milligan as a student and then served in various roles during his 50-year tenure, including professor, coach, athletic director, residence hall director, and even as dean of men. As a student-athlete, he participated in five sports and currently holds the school record for most varsity letters, 12. He retired from Milligan College in 2001, and in his final year, he was named the NAIA Athletic Director of the Year.

WOMEN'S INTERCOLLEGIATE SPORTS. Dr. Pat Bonner was largely responsible for establishing a women's intercollegiate athletic program at Milligan, as well as at the state level, as founder of Tennessee's College Women's Sports Foundation. From 1966 to 1998, she served as a professor, coach, director of intramural sports, and director of testing. Also influential in women's athletics were Rowena Bowers, who taught health and physical education, and Linda King Doan, who taught and led the women's volleyball team to many winning seasons in the 1980s and 1990s.

TEACHER EDUCATION. Dr. Paul Clark served as director of teacher education at Milligan from 1965 to 1998. Students and colleagues often heard his encouraging "Good for you!" He succeeded in gaining national accreditation for Milligan's teacher education programs, helped establish the college's first master's degree in education in 1988, and secured a grant to fund the education of minority candidates for the teaching profession.

DIBBLE. Dr. Terry Dibble taught English and humanities at Milligan from 1971 to 2001. Although he authored the Cliffs Notes Study Guide for *The Scarlet Letter*, Dr. Dibble was known for a thorough exploration of literature and a teaching style full of questions and stories. He led several humanities tours during his tenure, and he and history professor Tim Dillon could often be found in deep conversation with students at lunch in the cafeteria.

BERTRAM S. ALLEN JR. Bert Allen, class of 1967 and professor of psychology, has been a member of Milligan's faculty since 1979. Dr. Allen is a veteran of the US Army, having served in Vietnam with the 25th Infantry Division from 1968 to 1970. He has also served Milligan as chair of social learning and director of counseling and is particularly known for his interest in the well being of his students.

WINDOW CAPERS. Hart Hall resident assistants ham it up for the yearbook in 1980. Pictured clockwise from lower left are Tanya (Oakes) Babik, Terri Newton-Dewes, Candice (Thomas) Brown, Theresa (Pierce) Lemley, Ginny (Gwaltney) Guindon, Lisa Richardson, and Lisa (Voke) Hall. Each dorm at Milligan has a resident director (RD) and resident assistants (RA) to provide leadership, supervision, and programming for students.

CREEKING. From left to right, Kevin Haynes, Jerry Ackerman, Mike Fournier, and Scott Vecrumba capture classmate and Milligan historian Clint Holloway (being carried) as part of a longtime Milligan tradition of "creeking" friends when they get engaged. All but Haynes are 1995 alumni. Holloway and his bride, Adele (Adinolfi), had a classic Milligan romance, including an engagement proposal at the Hopwood Stump and a late-night dunking in Buffalo Creek.

HART HALL LADIES. Delta Kappa Women's Service Organization poses outside Hart Hall in the 1990s. The largest residence hall on Milligan's campus, Hart houses over 180 women and was completed in 1965. The dorm was a gift of Dr. John Hart and Pearl Hart in memory of his parents, Tecora Billingsley Hart and Charles Bissell Hart.

THE "RABBI." William C. Gwaltney Jr. joined Milligan's faculty in 1964 and served the institution for over 30 years. He held the Joel O. and Mabel Stephens Chair of Bible, and received the Fide Et Amore, the college's highest award, in 1998. He was instrumental in establishing the Fellowship of Professors, an organization of Bible and related-discipline faculty members serving in educational institutions associated with the Christian Church/Church of Christ.

SWEETHEART CONVOCATION. Doctors Bill Greer (left) and Bob Mahan perform as "Willamena" and "Roberta" during the annual event that included humor, skits, and music and was often emceed by professors. Sweetheart Convo started in the early 1950s in conjunction with Valentine's Day. In 1982, competition was opened up to include men (who, that year, appeared in suit coats, ties, dress shirts, and boxers.)

JOSEPH P. McCORMICK. Joe McCormick's long and varied history with the college began when he was a Milligan star athlete. A 1926 graduate, he served as a trustee (including a time as chair) from 1936 until 1956. In 1956, "Joe Mac" began a 35-year stint as assistant to the president. He raised funds for the college, serving until his death at age 90. The McCormick Dining Center is named in honor of him and his wife, Lora.

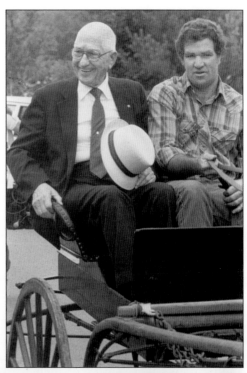

McMAHAN STUDENT CENTER. Built in 1987 with a gift from Grace Hart McMahan in memory of her husband, John, the center includes a snack bar, lounge, bookstore, recreation room, and offices for the Student Government Association and the services of Student Development, under the leadership of Vice Pres. Mark Fox. The Institute for Servant Leadership and Information Technology are located on the lower level.

HUMANITIES TOUR. The option of earning four hours of humanities credit by participating in a spring preparation course and a multi-week summer tour of Europe is a favorite alternative to a regular humanities course at Milligan. Historical and cultural sites are visited within several European countries, and lectures, discussions, and writing assignments are also part of the experience. The trips are led by Milligan humanities professors and have become a greatly anticipated tradition.

PAXSON COMMUNICATIONS CENTER. In 1989, the old Student Union Building was redesigned (and subsequently renovated in 2009) to become the Lowell "Bud" Paxson Communications Center, so named because of a major gift from Paxson, founder of the Home Shopping Network. The center contains a multimedia lab, video edit bays, a convergent newsroom, radio and television stations, and a control room. Seen here is a class taught by Carrie Swanay.

PARDEE ROWDIES. Pictured here in 1989 are, from left to right, Orrin Sumatra, Brian Hall, Ted Booth, Brian Clark, and Robert Dearmon, some of the last of the Pardee Rowdies. Built in 1919, Pardee Hall was in poor condition by the early 1990s. In its final decades, Pardee was considered the home of the Rowdies, its residents appropriately nicknamed for their love of all things fun, including toga parties, waterslides, and campus pranks.

COACH LINDA KING DOAN AND VOLLEYBALL TEAM. The volleyball program began under the Volunteer State Athletic Conference and now plays within the Appalachian Athletic Conference. Numerous players have been chosen All-Conference and All-Regional and have earned All-Academic Conference and All-American Academic awards. The team has also received the prestigious Champions of Character a ward for their volunteer service with groups such as the American Red Cross, the Boys and Girls Club, and the Salvation Army.

WILLIAMS CEMETERY, 1990s. Behind the Baker Faculty Center rest century-old graves, overseen by an association organized in 1986 by librarian John Neth. Josephus Hopwood once wrote that Lucy Jean Kinney, age eight, studied music while her mother attended classes. The vivacious little girl excelled in her efforts and was to perform at commencement but suddenly contracted diphtheria and died within days. Her marker is on the corner nearest the Clark Education Building.

HYDER HOUSE. The former home of mathematics professor Sam Jack Hyder was once called "Aftermath" and was used as student housing until it became offices for Institutional Advancement personnel. Several Milligan village houses, such as those known as Crouch Memorial Building, Wolf Hall, Stahl Hahl, and Paradise Hall, as well as the Brown, Rector, Fontaine, and Oakes homes, were acquired over the years and used as living quarters, offices, and studios for faculty, staff, and students.

TWIRP. Every autumn at Milligan brings TWIRP week, when campus coeds are encouraged to reverse traditional dating rules and do the asking. Started in 1951, TWIRP ("The Woman Is Required to Pay") activities have included movie night, a bonfire, an evening in the SUB, or a concert. Some Milligan couples, including president Bill Greer and his wife, Edwina (shown here), can trace the origin of their relationship to a TWIRP date.

KEGLEY HALL DEDICATION, 1993. Dean of students John Derry (left) and 1941 graduate James Kegley, owner of Tenneva Food and Supply of Bristol, Virginia, cut the ribbon on the residence hall that is a twin to Quillen Hall, named for longtime state representative Jimmy Quillen. Williams Hall is named for US federal judge Glen Morgan Williams, a 1940 Milligan graduate. The Kegley Honorary Chair of Business and Economics, held by Dr. Bill Greer, was established in 1995.

WOMEN'S TENNIS, 1994. From left to right on the ground are coach Richard Aubrey and Gina Adams, and across the car are Monica Click, Cindy Little, Jodie Iwanusa, Angie Armstrong, Laura Campbell, and Kristal Dove. Several of these athletes were also on the 1996 team that competed in the national tournament. The tennis courts shown here, located across from the Welshimer Library, were a gift from the Hoover/Price family in 1938.

HONORING THE HERITAGE. Students visit Alexander Campbell's grave in Bethany, West Virginia, during an annual "refo trip" with Prof. Dennis Helsabeck. Milligan students represent a multitude of religious backgrounds, but the college's foundation rests in the work of Campbell, an early leader in the Second Great Awakening. Though more than 400 educational institutions were started in the mid 1800s within the Stone-Campbell Restoration Movement, Milligan is among the few maintaining that Christian emphasis.

MADRIGAL CHRISTMAS DINNER. The Madrigal Christmas Dinners, established in 1967 under the direction of Sherwyn Bachman and William Moorehouse, were held each December in the dining room of Sutton Hall. Staged as a celebration of 16th-century English holiday customs, the events were an annual highlight to thousands. Because the response was so tremendous, additional performances were added, and other themes were eventually incorporated. The tradition continued for 35 years.

SOFTBALL. Under longtime coach Wes Holly, the Lady Buffs softball team has consistently ranked in the conference top three and has won several titles, as well as having produced many All-Conference and All-Regional players. The team also is recognized for its service to the Appalachian Christian Village and its work with local Boys and Girls Clubs.

HELICONCERT. Milligan staff members (from left to right) Ann Easter, Melissa Ford, and Nancie Rogers performed a spoof of Aretha Franklin's hit "Respect" as part of the annual Heliconcert that celebrated the arts. The event accompanied the *Helicon* literary magazine, a student work of creativity in music, art, photography, prose, and poetry. Begun in 1969 as *Faire le pont*, the *Helicon* later became the *Phoenix*.

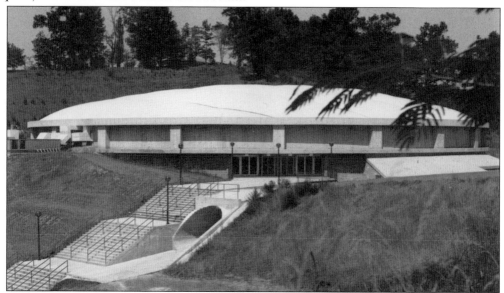

STEVE LACY FIELDHOUSE. The fieldhouse was completed in 1975 and named for 1931 Milligan graduate Steve Lacy, a former coach, dean, vice president, trustee, and chairman of the board. Unique with its air-suspended, Teflon-coated fabric roof, the structure was featured around the world as a prototype for buildings of the future. However, the fabric was eventually replaced with a conventional roof.

112

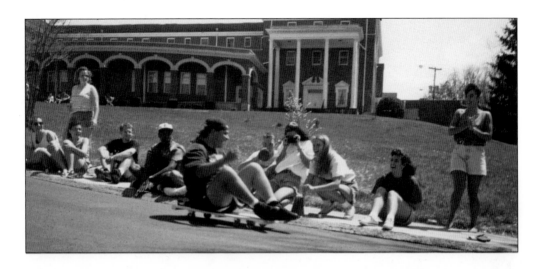

WONDERFUL WEDNESDAY, 1997. Though it has sometimes become Marvelous Monday or Terrific Tuesday, the tradition of a student holiday announced as a last-second surprise officially began in 1969 with an early morning proclamation by Pres. Jess Johnson on the chapel steps. However, the tradition echoes former Hopwood times when an outing was planned each term. Students of yesteryear enjoyed picnic trips to the Watauga River, the Rock House and Saltpeter Caves, Buffalo Mountain, and other local places. Today's students are notified of Wonderful Wednesday by email. The annual spring event has grown to include a variety of fun themed activities, but almost always includes a recreation of the waterslide improvised on the sloping lawn at Pardee Hall, a tug-of-war across Buffalo Creek, and a trip to the State Line Drive-In theater in Elizabethton.

DR. DON JEANES. Jeanes and his wife, Clarinda, both graduated from Milligan, where he also served in student life, financial aid, and the business office while continuing his education. He served elsewhere as a faculty member, administrator, and minister before returning to Milligan as president in 1997. During his 14-year tenure, Milligan achieved record enrollment, enlarged the campus to 195 acres, renovated older buildings, built new ones, expanded its master's programs, and achieved professional accreditation for others.

CROSS COUNTRY/TRACK AND FIELD. Coach Duard Walker began the cross-country program in 1961. His teams won seven consecutive Volunteer State Athletic Conference Championships from 1962 to 1968. The men's and women's programs have continued to enjoy success under coach Chris Layne, earning numerous national championship qualifiers and All-American honors. In 2003, freshman Marta Zimon, shown on right, earned Milligan's first national title in any sport by winning the 5,000-meter NAIA indoor title.

SOCCER. The Lady Buffs became part of the Milligan soccer program in 1997 and have since won multiple titles. Their yearlong weight and fitness training program equips them for their demanding season. Along with several All-American, All-Region, All-Conference, and Conference Player of the Year individual honors, the program has also had National Team Players. (Photograph by Danny Davis.)

WOMEN'S BASKETBALL. Rich Aubrey, recognized with multiple Coach of the Year awards, has led the Lady Buffs basketball team to several conference championships and tournament titles. They hold the distinction of going undefeated during the conference regular season more than once. Aubrey and the Lady Buffs also hold multiple consecutive Champions of Character awards for their community service to local schools, churches, and nonprofit organizations. (Photograph by Danny Davis.)

SERVING APPALACHIA. Milligan's heritage includes a rich history of ministry to the region, offering service through established programs and student-initiated outreach. Through Milligan affiliations with organizations like the Appalachia College Association, students such as (left to right) Jessi Bryant, Jessi Pansock, and Rachel Lee, who did research for Appalachia Service Project's low-income home-repair effort, benefit from experiences outside the classroom. Mission and ministry efforts at home and abroad are regular activities.

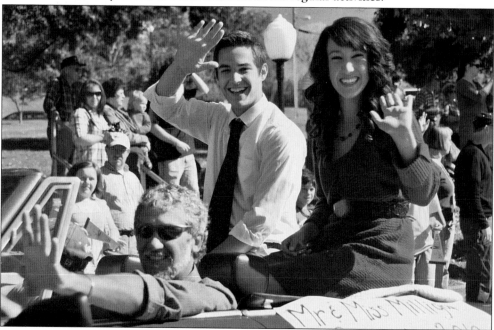

MR. AND MISS MILLIGAN. Shown here are 2010 annual Homecoming candidates Ben Richardson and Michelle Ramsey riding in the 2010 annual parade. Crowning a homecoming queen and king was a tradition during the years of Milligan's football program, but it transitioned to designating a Founder's Daughter, who embodied specific Christian ideals, for the subsequent Founder's Day event that was started in 1951.

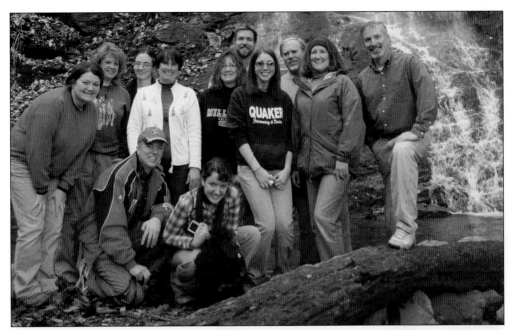

LEE AND PAT MAGNESS. Professors Lee and Patricia Magness (third and second from right) began serving at Milligan in 1983 and 1984, respectively. Lee holds the Vera Britton Chair of Bible. Pat is professor of humanities and area chair of humane learning. Sometimes collectively referred to as the "Magnii," they are known for compassionately involving themselves in the lives of students.

DR. JACK L. KNOWLES. Knowles, a Shakespearian scholar, is a Milligan graduate who began teaching English and humanities at the college in 1970. He goes beyond the classroom and has participated in theater, coached tennis, refereed student-alumni football games, led humanities tours, chaired the humanities program, advised SGA, and served on numerous committees over the years. He is known for his witty humor, thorough preparation, and careful decision-making skills.

FINE ARTS. The arts have been a major component of Milligan studies from its very early years, but an official art department began when Emma Shelor taught drawing and painting in 1886. All students study the arts through the humanities program, but individuals who major in an area such as visual art, film studies, music, and theater are offered greater opportunity to explore and develop according to their talents and interests.

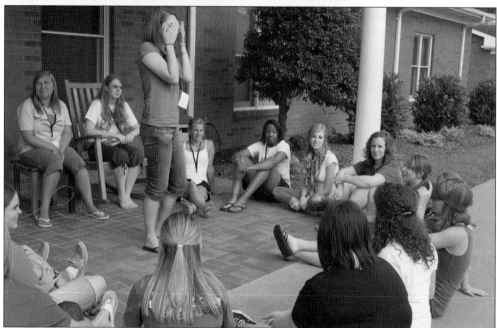

CAMPS AND MINISTRY TO YOUTH. Along with a fine arts camp, Milligan, for many years, has offered younger students the chance to develop their skills and knowledge in a variety of areas through summer camps and unique retreats that focus on individual sports, spiritual growth, and special interests. Its Youth in Ministry outreach, established in 2002 with Lilly Endowment, Inc. funding, has encouraged teens throughout the years to discover their calling as a servant leader.

HOMECOMING. 1958 graduate Al Covell proudly wears his Milligan letterman sweater to Homecoming in 2005. An annual celebration featuring reunions and events for alumni of all ages, Homecoming became Alumni Weekend after the demise of football. The autumn weekend was renamed Homecoming in the early 2000s and now also features an annual parade, an alumni-versus-student flag football game, athletic games, and even carnival activities for children.

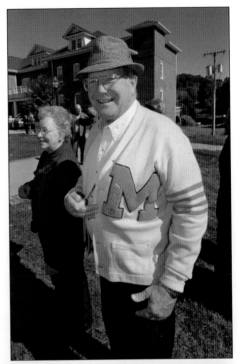

MASTER OF BUSINESS ADMINISTRATION. Milligan's MBA program was founded by Pres. Bill Greer, then professor of economics, in 2004. As the college catalog states, "Ethics and Christian teaching are woven throughout every course in the program. The emphasis throughout is on integrating practical business skills with a concern for ethics, professional responsibility, and leadership development." The program, designed for working professionals, meets one Saturday each month, complemented by ongoing Internet instruction.

McGlothlin-Street Occupational Therapy Center. Named for donor Jim McGlothlin, founder of United Company, and his cousin Nick Street, the center is located in the lower level of Hardin Hall and houses the master of science in occupational therapy program, which prepares its graduates to help individuals prevent or live better with illness, injury, or disability.

Tennis Center. Dedicated in 2005 to honor 1942 alumnus Dr. W.T. Mathes, the center has six lighted courts and a 4,000-square-foot clubhouse with an observation deck, completed in summer 2010. Coach Ryan Reynolds and the tennis teams benefit from the convenient new locker rooms and ease of court observation, but others enjoy the facility as well.

DR. YOUNG. Distinguished alum Ben Young also studied at Pepperdine University before earning a medical degree from Howard University. His outstanding accomplishments include serving administratively at John A. Burns School of Medicine, the University of Hawaii-Manoa, and Castle Medical Center prior to his 2007 retirement. Additionally, Dr. Young served on the US Surgeon General's Committee on the Prevention of Violence and as president of the National Council for Diversity in the Health Professions.

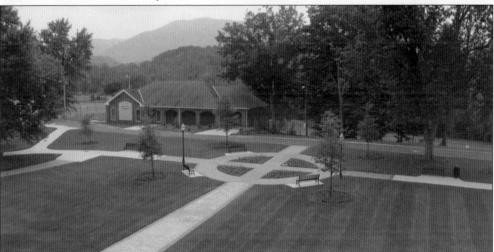

MARY SWORD COMMONS. Mary Sword Jarvis affectionately remembered the beautiful gardens at the fish pool as the place where the young ladies could visit with the young men during evening "conference hour." A chemistry course at Milligan inspired her to earn a chemistry degree after marriage, an experience later leading her to provide scholarships for older women. Her family funded the Celtic cross walkway and named the campus commons in her honor.

CELTIC CROSS. Designed and crafted by artist Stefan Bonitz of Asheville, North Carolina, the 18-foot-tall, 8,000-pound cross was installed on the commons in 2010, with funding from longtime Milligan supporter Mary H. Phillips. Reflecting the Milligan logo and representing the college's Christian commitment and heritage, the Celtic cross is incorporated into many aspects of campus, such as in the adjacent commons walkway and on the spire of Seeger Memorial Chapel.

BOOKSTORE. Textbook manager Jonathan Toler is shown in the bookstore of the McMahan Student Center, built in 1987 with a gift from Grace Hart McMahan to honor her husband, John. In 1913, the campus bookstore was located in the Classroom Building, and then in 1954, it moved from the little campus store to the newly built Student Union Building.

JOE G. WHITAKER. Whitaker, a master storyteller and frequent auctioneer for the annual faculty auction, attended Milligan in the mid-1960s and served the college for over 20 years. With backgrounds in business, education, and the ministry, his wisdom and business acumen was instrumental in managing much of the college's growth. As shown here on Campus Workday, he was a servant leader. He retired in 2011 as vice president for business.

BUFFALO STATUE. Theresa Garbe, director of alumni relations, stands with one of the herd. Gifted in 2009 by six alumni, the 4,000-pound statue, anchored in concrete on the lawn of Derthick Hall, is regularly decorated by students for the holidays. The generosity of Milligan alumni reflects their enthusiasm for and pride in their common heritage. Milligan's alumni support is significantly higher than most colleges in the United States.

TAYLOR/PHILLIPS HOUSE. Containing the original pre-1796 log cabin, this historic structure has been home to many key Milligan figures, including the Williams, Taylor, and Barker families, and is now Milligan's hospitality and reception house. It was renovated in 2002 under the direction of first lady Clarinda Jeanes and placed under the wing of the Associated Ladies for Milligan. Its name also honors the sons of B.D. Phillips: Ben, Victor, and Don. (Photograph courtesy of Brandon Hicks, *Elizabethton Star*.)

FIRST LADY. Clarinda (Phillips) Jeanes is a 1971 graduate of Milligan and was Milligan's first lady from 1997 to 2011. In addition to renovating the Taylor/Phillips House in 2002, she helped beautify campus, directing the landscaping crew, spending countless hours planting flowers, and sprucing up the college's facilities. She founded the Associated Ladies for Milligan group, which hosts numerous activities each year to raise additional scholarship funds for Milligan students.

GREGORY CENTER FOR THE LIBERAL ARTS. During the Jeanes administration, the impressive Elizabeth Leitner Gregory Center was erected as home to the theater arts program, the humanities program, the Welshimer lecture series, and additional campus events held in its 294-seat auditorium. It is named for the grandmother of Joe and John Gregory, staunch supporters of Christian education. One classroom is named for 1938 alum John Willis, a Tony Award winner and editor of *Theatre World*.

MARVIN GILLIAM WELLNESS CENTER. As part of the Forward Ever campaign established under the Jeanes administration, the energy- and environment-friendly facility was funded by Richard and Leslie Gilliam and named to honor Richard's father, a 1938 Milligan graduate and lifelong teacher. The state-of-the art equipment was provided by alumni Denny and Cindy (Keefauver) Mayes, promoting wellness and a healthy lifestyle through the center's many opportunities for exercise and active participation in classes and games.

DRS. DON JEANES AND BILL GREER. Bill Greer assumed the Milligan presidency in July 2011, coming from an extensive and distinguished professional background in academics and business. He earned an MBA from East Tennessee State University and a PhD in economics from the University of Tennessee, Knoxville. His experience as church elder, businessman, and community servant provides a sound foundation for leadership. Greer graduated from Milligan in 1985 and joined the faculty in 1994, teaching economics and chairing the business area for several years. Together, Jeanes and Greer have established and nurtured relationships with supporters of the Milligan College family, who have assisted in making the college what it is today. As the Christian education offered at Milligan continues to help foster the "hope of the world," Milligan College moves, in the words of its alma mater, "Forward Ever."

BIBLIOGRAPHY

Cornwell, Cynthia Ann. *Beside the Waters of the Buffalo: A History of Milligan College to 1941*. Johnson City, TN: Milligan College History Project, Overmountain Press, 1989.

Holloway, Clinton Jack. *Age Deo Fide et Amore: A History of Milligan College, 1940–1968*. Thesis (MA), Emmanuel School of Religion, 1998.

Hopwood, Josephus. *A Journey through the Years, An Autobiography*. St. Louis, MO: The Bethany Press, 1932.

Leggett, Marshall. *A Love Affair with Milligan, The Presidency 1982–1997, An Anecdotal Memoir*. Privately published, 2008.

Stout, B. Harold. *A History of Intercollegiate Athletics at Milligan College, 1887–1973*. Thesis (MA), East Tennessee University, 1974.

www.arcadiapublishing.com

Discover books about the town where you grew up, the cities where your friends and families live, the town where your parents met, or even that retirement spot you've been dreaming about. Our Web site provides history lovers with exclusive deals, advanced notification about new titles, e-mail alerts of author events, and much more.

MADE IN THE USA

Arcadia Publishing, the leading local history publisher in the United States, is committed to making history accessible and meaningful through publishing books that celebrate and preserve the heritage of America's people and places. Consistent with our mission to preserve history on a local level, this book was printed in South Carolina on American-made paper and manufactured entirely in the United States.

This book carries the accredited Forest Stewardship Council (FSC) label and is printed on 100 percent FSC-certified paper. Products carrying the FSC label are independently certified to assure consumers that they come from forests that are managed to meet the social, economic, and ecological needs of present and future generations.

FSC

Mixed Sources
Product group from well-managed
forests and other controlled sources

Cert no. SW-COC-001530
www.fsc.org
© 1996 Forest Stewardship Council

Find Your Place in History.